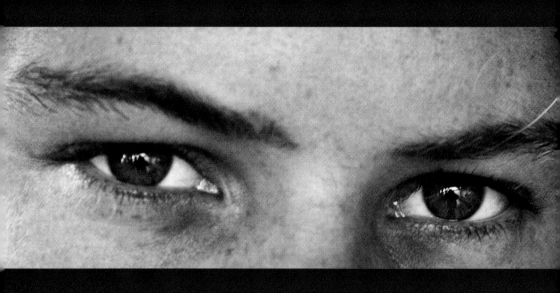

THE BREWER

DESIGNED AN

PHOTOGRAPH BY
BRUCE WEBER

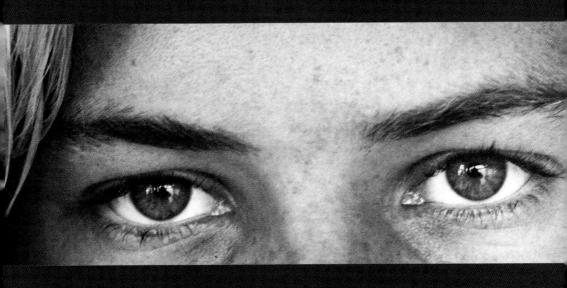

TWINS
DOUBLE TAKE

EDITED BY PAUL WEST AND JASON LOSSER

UNIVERSE PUBLISHING

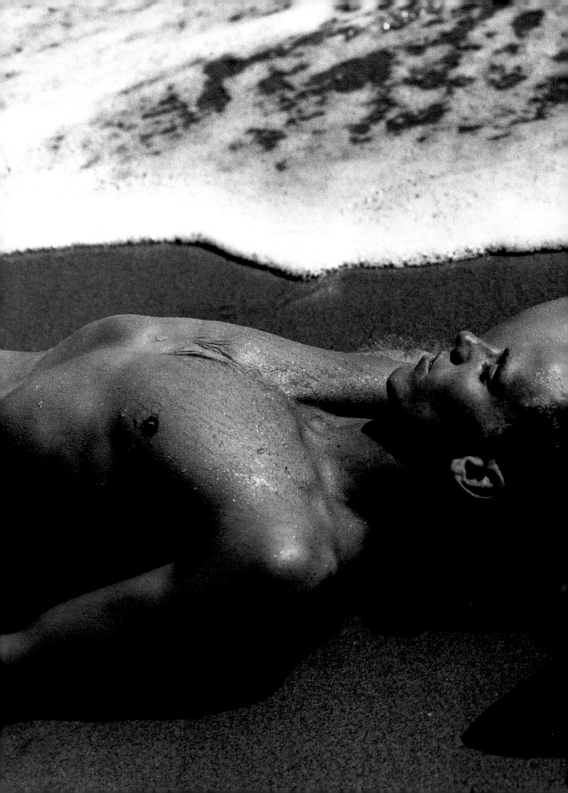

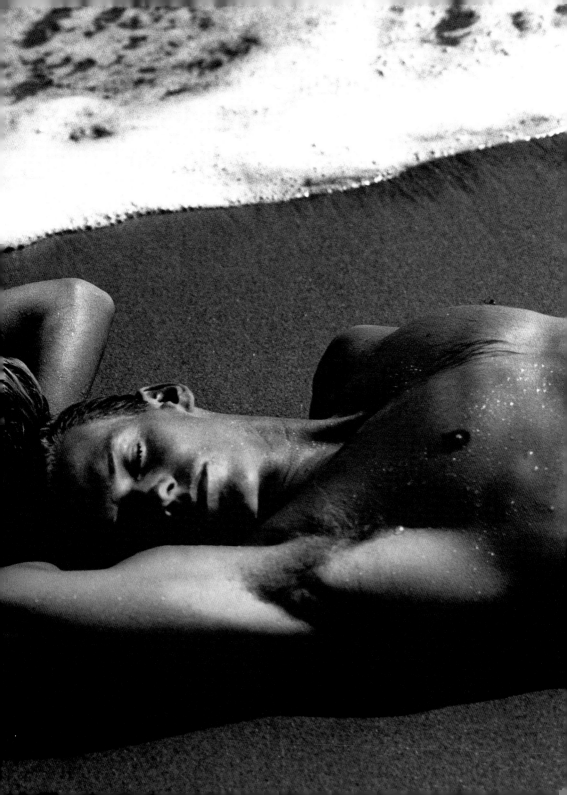

TO HARLEN DRUM, OUR GRANDFATHER

FIRST PUBLISHED IN THE UNITED STATES OF AMERICA IN 1998
BY UNIVERSE PUBLISHING
A DIVISION OF RIZZOLI INTERNATIONAL PUBLICATIONS, INC.
300 PARK AVENUE SOUTH
NEW YORK, NY 10010

98 99 2000/10 9 8 7 6 5 4 3 2

LIBRARY OF CONGRESS CATALOG CARD NUMBER: 98-060411

DESIGNED AND EDITED BY PAUL WEST AND JASON LOSSER

PRINTED IN SINGAPORE

PREVIOUS PAGE:
PHOTOGRAPH BY
MARKO REALMONTE
RIGHT:
PHOTOGRAPH BY
VICTOR SKREBNESKI

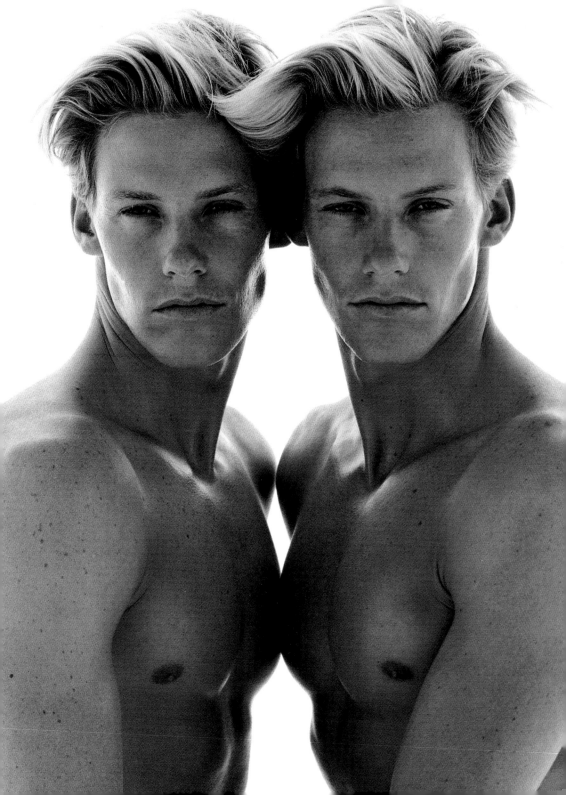

TWO

NG

E

WHO

TWINS.COM

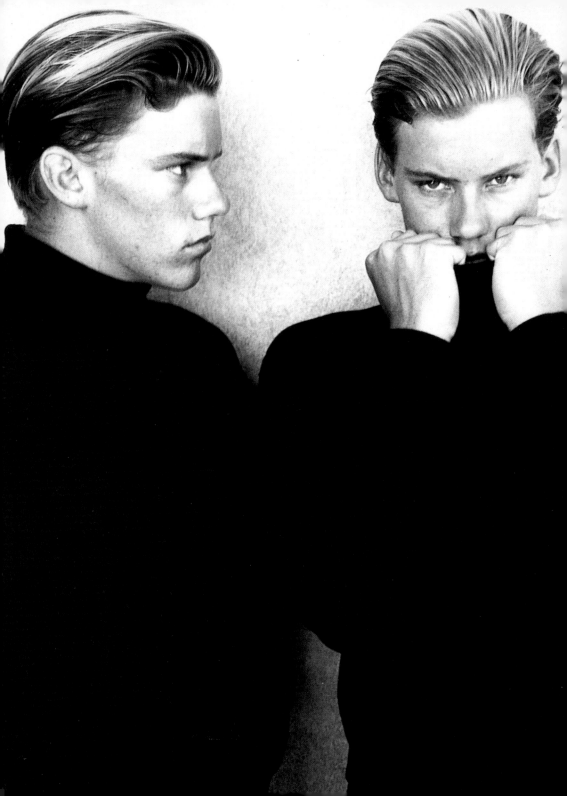

INTRODUCTION

THIS BOOK TELLS OUR STORY, IN WORDS AND PICTURES, FROM OUR EARLY DAYS GROWING UP NEAR HERMOSA BEACH TO OUR LATEST ADVERTISING CAMPAIGNS. WE SHARE THE HIGHLIGHTS OF OUR MODELING CAREER, INCLUDING OUR FIRST BIG BREAK (A SHOOT BY STEVEN MEISEL THAT APPEARED IN ITALIAN GLAMOUR); APPEARANCES ON COVERS SUCH AS SASSY AND ESQUIRE; AND OUR MOST HIGH-PROFILE SHOOT, WITH CINDY CRAWFORD.

WE ALSO SHOW HOW WE SPEND OUR TIME WHEN WE'RE NOT WORKING, FROM SNOWBOARDING TO BEACH VOLLEYBALL TO OUR NUMBER-ONE PASSION—SURFING. BUILDING AND MAINTAINING OUR OFFICIAL WEBSITE IS ANOTHER WAY WE SPEND OUR TIME; HERE, WE GIVE YOU A GUIDED TOUR. LAST, BUT NOT LEAST, WE REVEAL THE ANSWERS TO THE QUESTION WE HEAR MOST: HOW CAN YOU TELL WHO'S WHO?

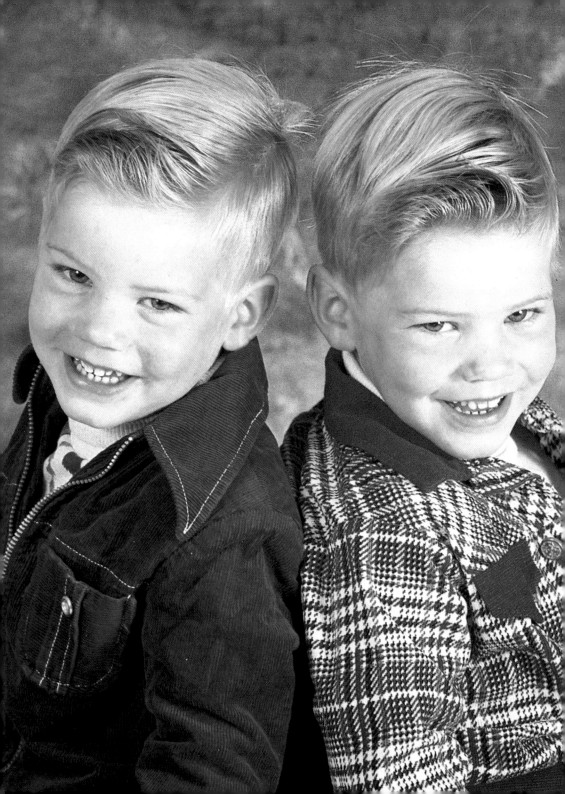

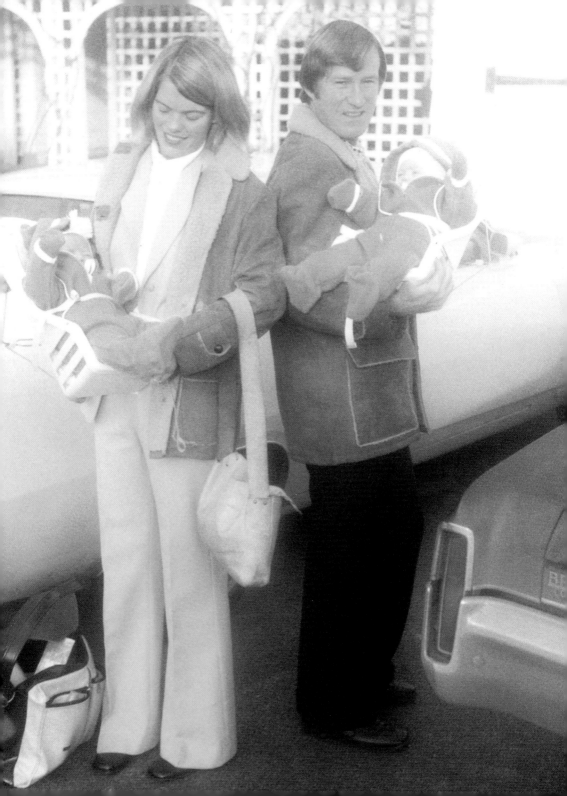

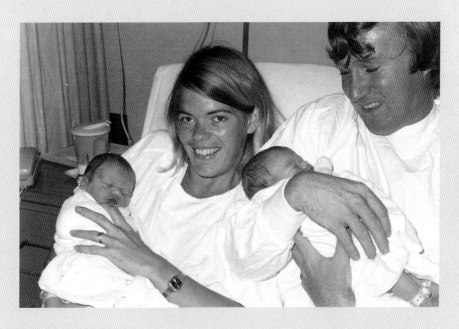

WE WERE BORN ON SEPTEMBER 21, 1973, AT TORRANCE MEMORIAL HOSPITAL IN SOUTHERN CALIFORNIA. THE DOCTORS (AND OUR PARENTS) DIDN'T KNOW THAT OUR MOTHER WAS PREGNANT WITH IDENTICAL TWINS BECAUSE DURING THE SONOGRAMS OUR HEARTS WERE BEATING IN UNISON. AFTER DEREK WAS BORN, THE DOCTORS BEGAN TO WASH UP, BUT OUR MOTHER WAS STILL IN A LOT OF PAIN. FIFTEEN MINUTES LATER, KEITH WAS BORN.

WHEN DAD CALLED HIS FATHER-IN-LAW TO SHARE THE NEWS, GRANDPA ASKED, "IS IT A BOY?" NO. "IS IT A GIRL?" HE ASKED. WRONG AGAIN. POOR GRANDPA WAS COMPLETELY BAFFLED BY THE TIME DAD TOLD HIM WE WERE BOYS—TIMES TWO!

BORN?

| KEITH: 3:10 A.M. |
| DEREK: 2:55 A.M. |

MIDDLE NAME? KEITH: WHITIN
DEREK: HARLEN

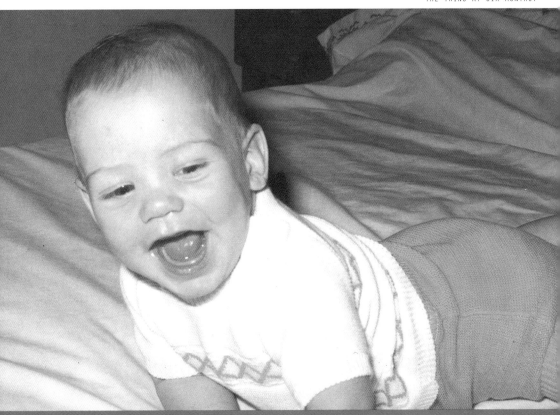

FIRST WORD?

KEITH: MAMA
DEREK: DITTO

OUR LOOKS CAME FROM OUR MOTHER:
BLOND HAIR, GREEN EYES.

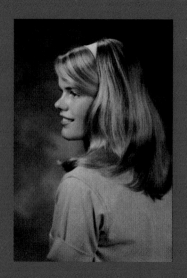

OUR BRAINS CAME FROM OUR FATHER:
AN AEROSPACE ENGINEER WITH
A PH.D. FROM UCLA.

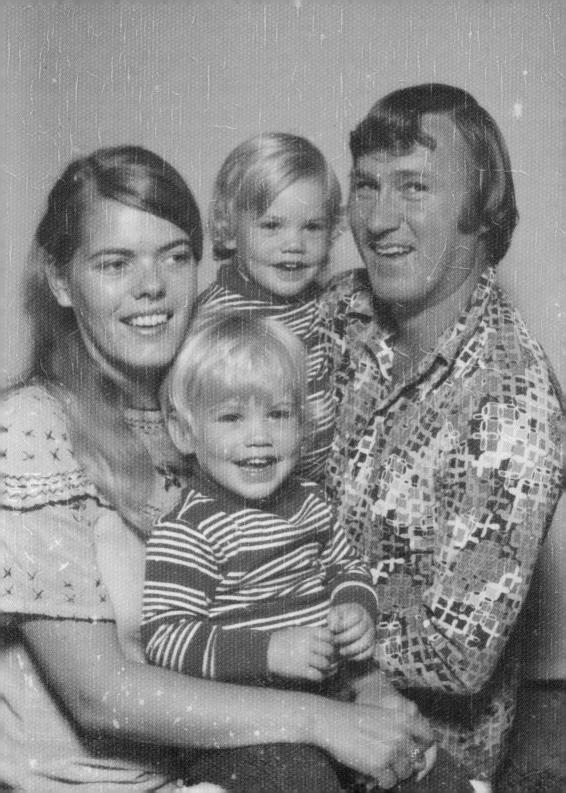

1977 1978

GROWING UP WITH A TWIN BROTHER WAS PRETTY
HAD EACH OTHER TO HANG OUT WITH. AND WE PLAY
IF ONE OF US WAS SUSPECTED OF TROUBLE BY A

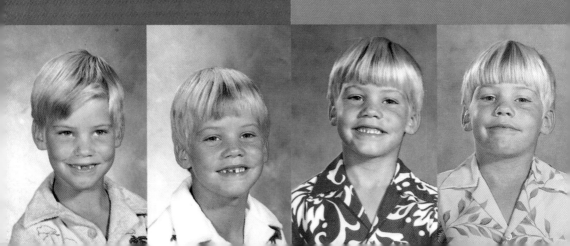

1980

1983

1981

1981

COOL. WE NEVER GOT BORED BECAUSE WE ALWAYS
ED TRICKS ON PEOPLE WITH OUR IDENTICAL LOOKS:
EACHER, WE WOULD JUST BLAME IT ON THE OTHER.

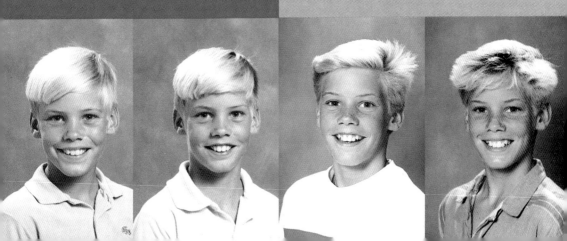

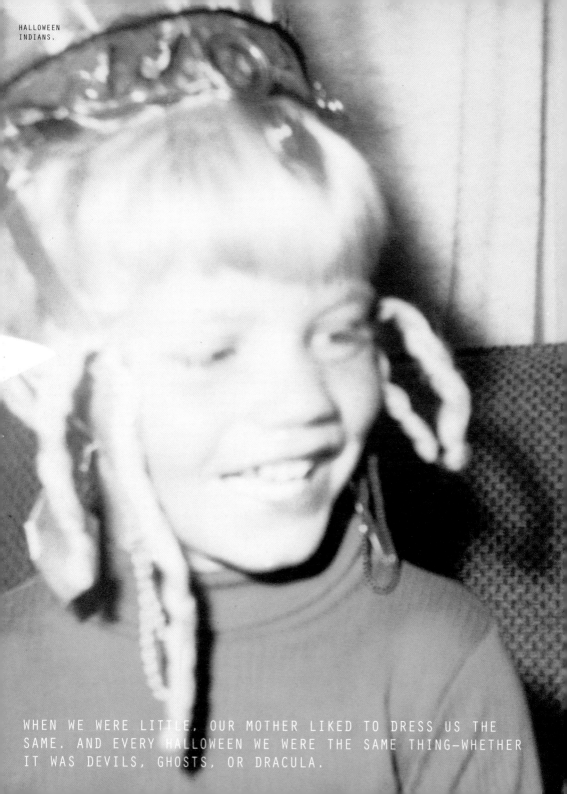

WHEN WE WERE LITTLE, OUR MOTHER LIKED TO DRESS US THE
SAME. AND EVERY HALLOWEEN WE WERE THE SAME THING—WHETHER
IT WAS DEVILS, GHOSTS, OR DRACULA.

BEST FRIEND?

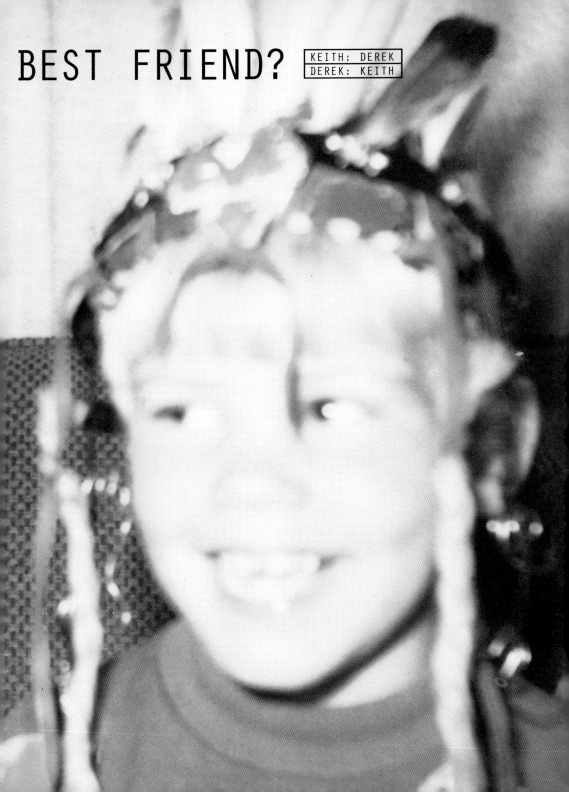

BASEBALL?

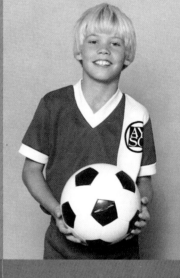

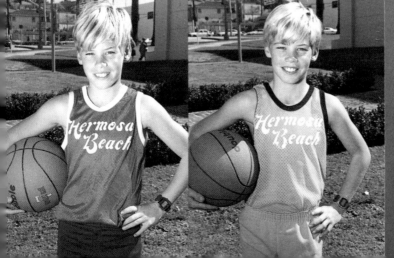

BASKETB

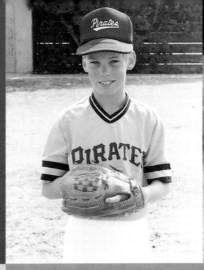

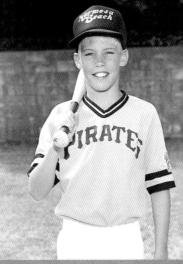

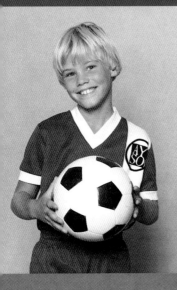

FAVORITE SPORT?

KEITH: SOCCER
DEREK: SAME

ALL?

KEITH: SCORED 2 POINTS ALL SEASON
DEREK: AVERAGED 10 POINTS PER GAME

Derek
1980

CHILDHOOD
CRUSH?

KEITH: ATHENA GIBSON
DEREK: APRIL CHRISTIE

Keith
1980

MEMORABLE
TEACHER?

KEITH: BEST—MRS. APPLEYARD, ENGLISH
DEREK: TOUGHEST—MRS. STRANGE, SCIENCE

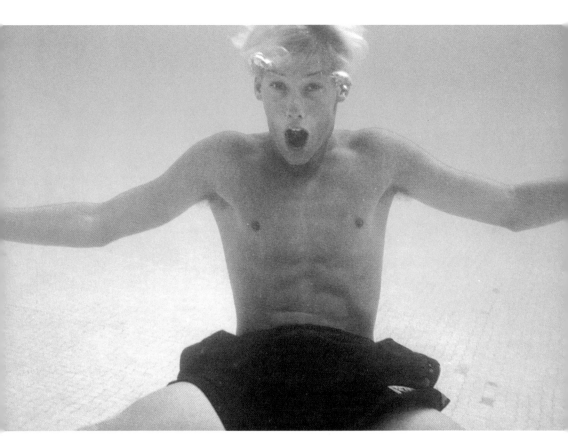

WE'VE ALWAYS LOVED ANYTHING TO DO WITH
THE WATER, AND WERE LUCKY TO GROW UP
WITHIN WALKING DISTANCE OF

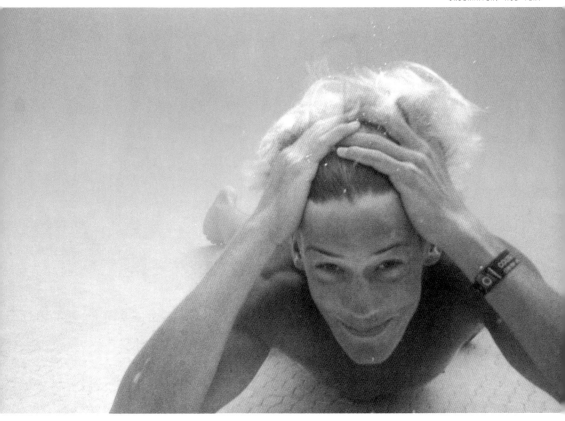

HERMOSA BEACH. WE CAUGHT OUR FIRST WAVES
ON BOOGIE BOARDS AT AGE FIVE, AND STARTED
SURFING WHEN WE WERE THIRTEEN.

Yancy Berns
Judith Bertea
Melissa Bertea
Jeffrey Biscornet

Erik Blomquist
Stacy Boelman
Christopher Bolin
Dalila Boussaid

Michael Boyce
Robert Bozzi
Andrew Brack
Traci Branch

Derek Brewer
Keith Brewer
Carl Brown
Colby Brown

Joshua Brown
Suzie Bruce
Aaron Burke
John Cabeza Devaca

Scott Cain
Peter Caird
Edgar Canal
Jessica Carson

ELEMENTARY: SOUTH ELEMENTARY, HERMOSA BEACH, CA
JUNIOR HIGH: HERMOSA VALLEY JUNIOR HIGH, HERMOSA BEACH, CA
HIGH SCHOOL: REDONDO UNION HIGH SCHOOL, REDONDO BEACH, CA

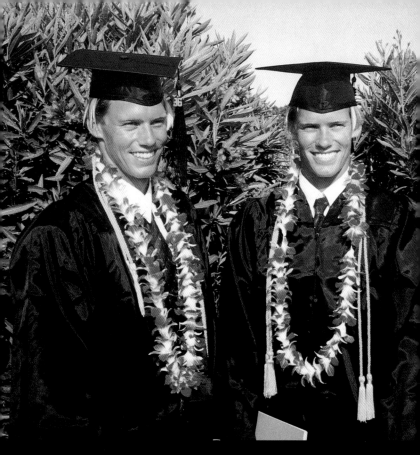

WE WERE AS COMPETITIVE WITH EACH OTHER IN SCHOOL AS WE WERE IN SPORTS. WE ALWAYS MADE THE DEAN'S LIST, AND NEITHER ONE OF US COULD TOLERATE THE OTHER GETTING A BETTER GRADE. WE BOTH GRADUATED FROM CALIFORNIA STATE UNIVERSITY DOMINGUEZ HILLS IN 1996 WITH FINANCE DEGREES, AND ONE DAY, WE WANT TO GO BACK FOR OUR M.B.A.'S.

G.P.A.?

| KEITH: 3.62 MAGNA CUM LAUDE |
| DEREK: 3.57 CUM LAUDE |

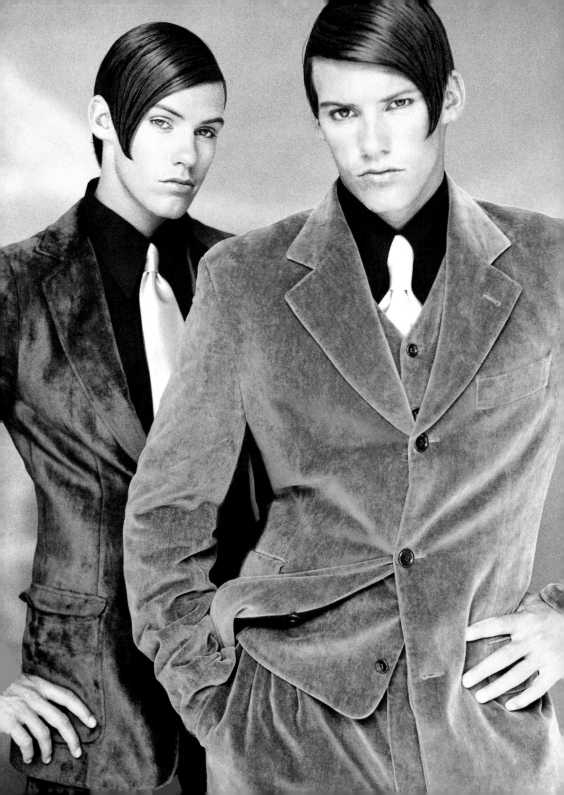

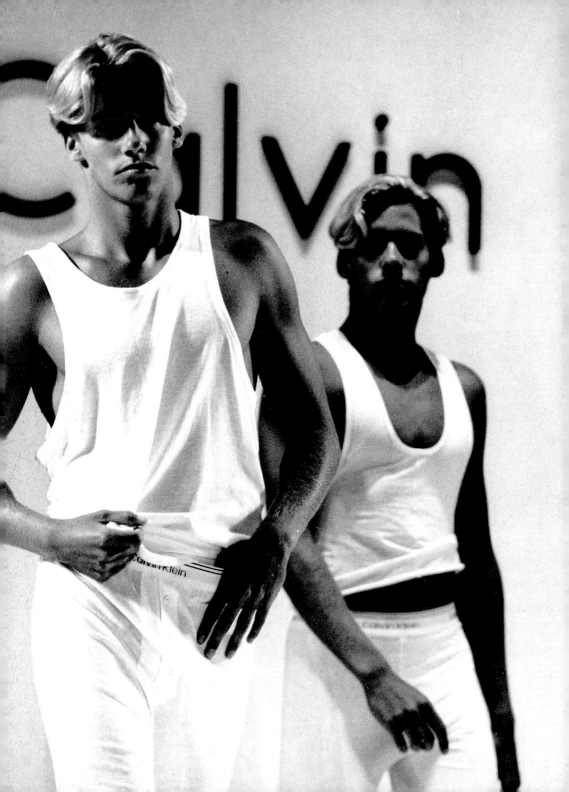

WHEN WE WERE KIDS, PEOPLE WERE CONSTANTLY TELLING OUR PARENTS THAT WE SHOULD WORK IN THE ENTERTAINMENT INDUSTRY. IT WASN'T UNTIL WE WERE SIXTEEN THAT WE TOOK THIS ADVICE SERIOUSLY. IN FACT, IT WAS A COMPLETE STRANGER WHO FINALLY SPURRED US TO SIGN UP FOR ACTING CLASSES AND FIND AN AGENT. WE DID A FEW COMMERCIALS (TRIDENT, OF COURSE), AND WHEN WE WERE EIGHTEEN, WE DECIDED THAT WE WANTED TO TRY MODELING.

WE WALKED INTO AN AGENCY IN LOS ANGELES AND, EVEN THOUGH WE DIDN'T HAVE A PORTFOLIO, THEY TOOK US ON. THE FIRST THING THEY DID WAS TAKE SOME POLAROIDS, WHICH THEY SENT TO AN IMPORTANT FASHION PHOTOGRAPHER. TWO WEEKS LATER, WE FOUND OURSELVES IN NEW YORK CITY SHOOTING THE COVER OF ITALIAN GLAMOUR WITH STEVEN MEISEL. THIS FIRST BIG SHOOT WAS LIKE A DREAM. THE PHOTOGRAPHER MADE US FEEL COMFORTABLE IN FRONT OF THE CAMERA, TREATING US LIKE OLD FRIENDS. AND WE STAYED IN A BEAUTIFUL HOTEL. WE KNEW WE WERE OFF TO A TERRIFIC START. BUT WE ALSO LEARNED THAT WE DON'T FEEL AT HOME IN NEW YORK CITY. WE DIDN'T KNOW UPTOWN FROM DOWN-, AND A FIFTEEN MINUTE WALK TOOK US AN HOUR ON THE SUBWAY.

SINCE THAT FIRST BREAK, WE'VE BEEN FORTUNATE TO WORK WITH SOME OF THE GREATEST FASHION PHOTOGRAPHERS—FROM PATRICK DEMARCHELIER TO HERB RITTS. NOT BAD FOR TWO BEACH BOYS!

PREVIOUS PAGE:
PHOTOGRAPH BY CARLOS ARMANDO
FOR UNITED ADVERTISING.
OPPOSITE:
FIRST SHOW—CALVIN KLEIN FOR
APLA BENEFIT AT HOLLYWOOD BOWL,
PHOTOGRAPH BY
MARKO REALMONTE.

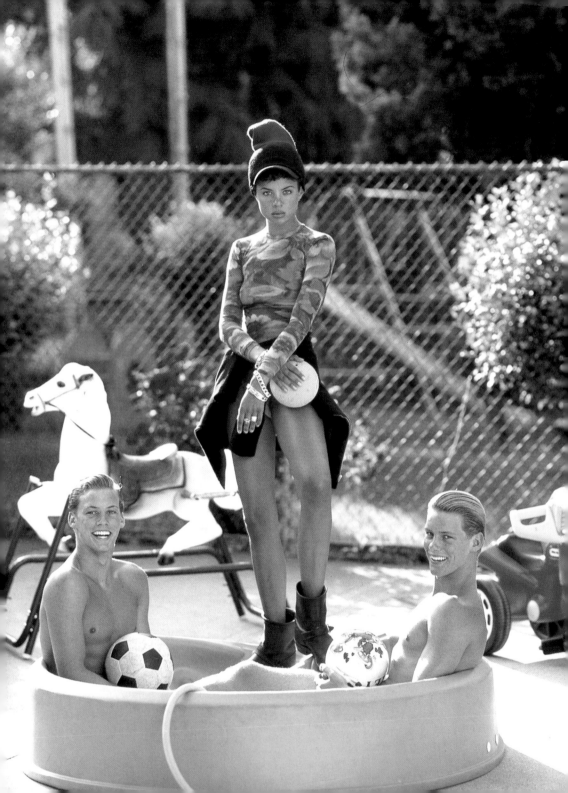

FIRST COVER

ITALIAN <u>GLAMOUR</u>
AGE: EIGHTEEN
WHERE: NEW YORK
PHOTOGRAPHER: STEVEN MEISEL

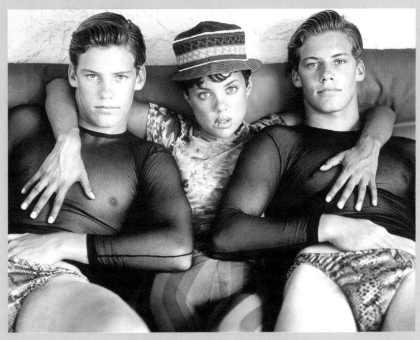

THE NEW YORK TIMES
SUNDAY, JUNE 13, 1993

"JUST NINETEEN YEARS OLD, KEITH AND DEREK BREWER OF HERMOSA BEACH, CALIFORNIA, HAVE ALREADY DONE CAMPAIGNS FOR THE GAP AND GUESS. THEIR FIRST SHOOT, WITH STEVEN MEISEL LAST SUMMER, LANDED THEM ON THE COVER OF ITALIAN <u>GLAMOUR</u>.

"THE PAIR SEEM TO THINK MAINLY ABOUT TWO THINGS: WOMEN AND SURFING....THEY HAVEN'T YET MET THOSE BLOND <u>PLAYBOY</u> COVER GIRLS, THE BARBIE TWINS, SIA AND SHANE, BUT THEY'D LIKE TO.

"AND, YES, ONE TWIN OFTEN PRETENDS TO BE THE OTHER. 'WE PULLED JOKES ON GIRLS.' KEITH BREWER SAID, 'BUT I'M NOT SURE IF WE SHOULD GET INTO DETAILS ON THAT.'"

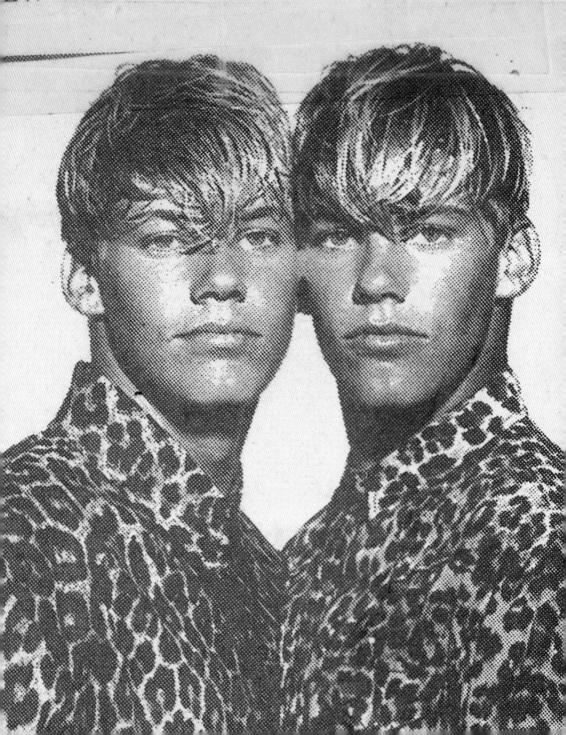

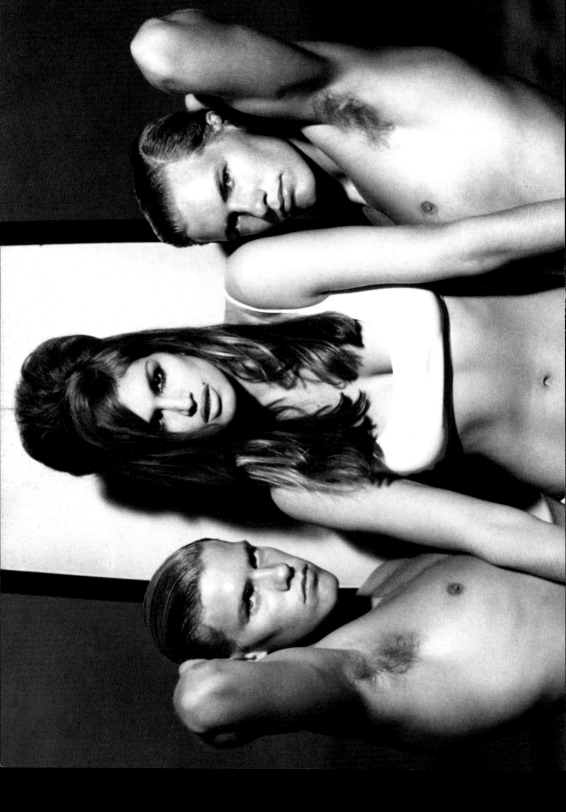

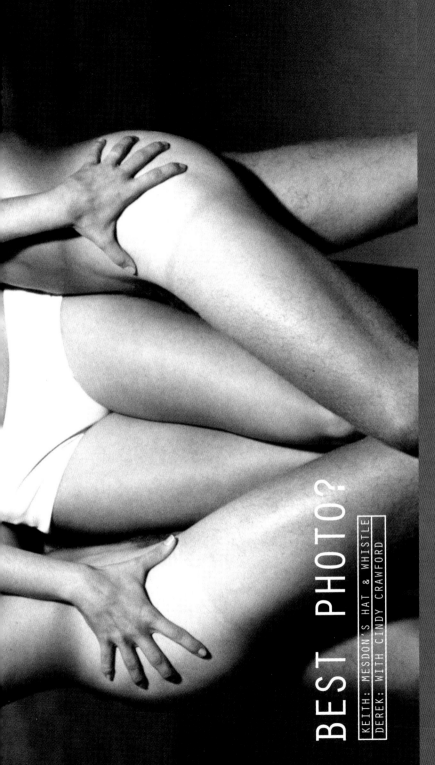

BEST PHOTO?

KEITH: MESDON'S HAT & WHISTLE
DEREK: WITH CINDY CRAWFORD

KEITH HAD A HISTORY FINAL THE DAY OF THE SHOOT. HE CALLED HIS TEACHER TO ASK HER IF HE COULD RESCHEDULE THE TEST. SHE WAS VERY SKEPTICAL OF HIS EXCUSE, BUT AGREED ON THE CONDITION THAT KEITH BRING BACK SOME PROOF. THE NEXT DAY, KEITH STRUTTED INTO CLASS WITH A POLAROID FROM THIS SHOOT.

HERB RITTS, ROLLING STONE

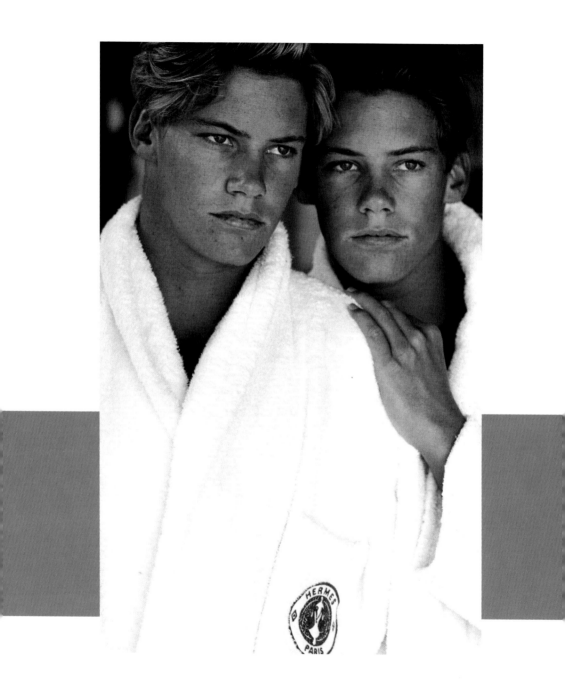

FIRST OVERSEAS TRIP

AGE: NINETEEN
WHERE: PARIS, FRANCE
WHY: RUNWAY SHOWS

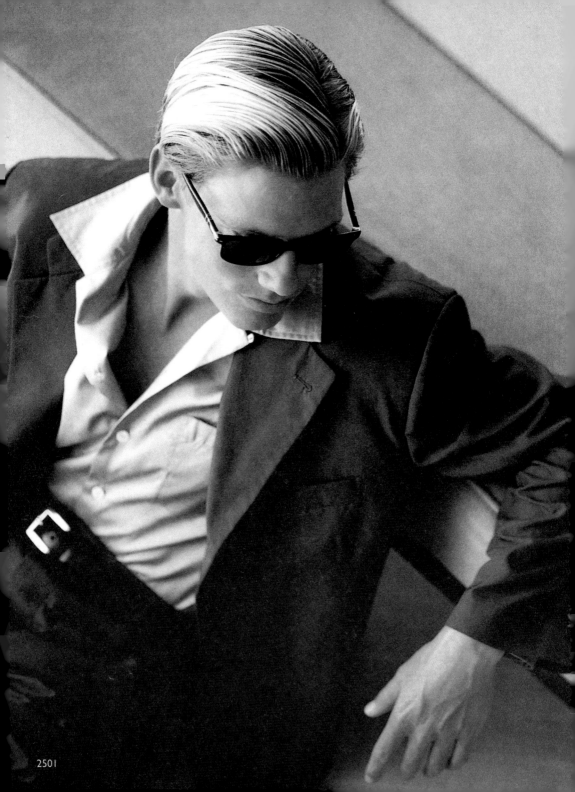

PEOPLE ALWAYS THINK WE'RE HIRED AS A PAIR, BUT IN FACT, WE'VE BOTH DONE CATALOGS AND AD CAMPAIGNS SEPARATELY. FOR EDITORIAL WORK, THE FACT THAT WE'RE TWINS IS GENERALLY AN ASSET.

PHOTOGRAPH BY
MICHAEL HERBERT
FOR LENSCRAFTERS

YvesSaintLaurent
pour homme

YvesSaintLaurent
pour homme

 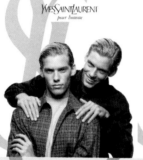 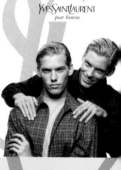

YvesSaintLaurent
pour homme

 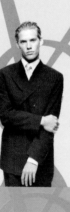 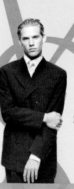 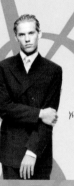

YvesSaintLaurent
pour homme

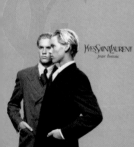 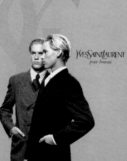 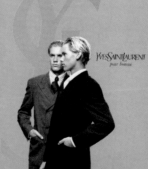 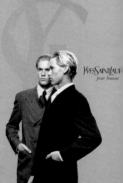

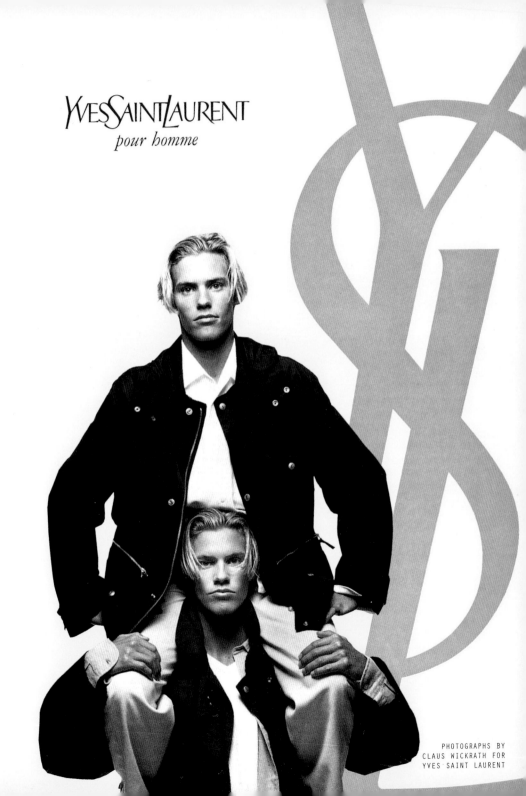

YVES SAINT LAURENT

pour homme

BRITISH ESQUIRE
CAPE TOWN, SOUTH AFR
PHOTOGRAPHER: MIKE F

MODELING HAS TAKEN
US ALL OVER THE
WORLD AND, DEPENDING
ON THE SEASON, WE
TRY TO BRING OUR
SURF- OR SNOWBOARDS
ON EVERY TRIP WE
TAKE. SOMETIMES WE
BRING BOTH. FROM A
SURFER'S PERSPECTIVE,
OUR BEST TRIP WAS TO
SOUTH AFRICA, WHERE
WE WERE PROMOTING
THE BOOK MALE SUPER-
MODELS. WE SHOT FOR
BRITISH ESQUIRE AND
SA MAGAZINES, BUT
THE HIGHLIGHT FOR US
WAS JEFFERY'S BAY,
WHERE WE CAUGHT SOME
OF THE BEST WAVES
OF OUR LIVES.

BEST LOCATION?

CA

ENN

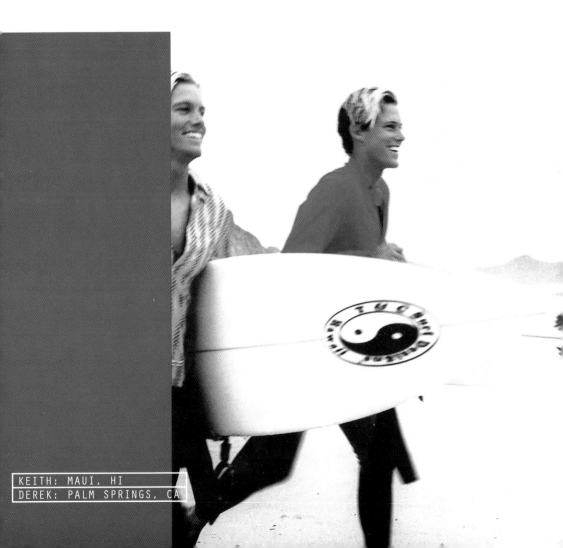

KEITH: MAUI, HI
DEREK: PALM SPRINGS, CA

esquire

GENTLEMAN

Special Issue · Fall 199

Twice as much fashion, half as much boring stuff

**Plus:
Peter O'Toole,
Steve McQueen,
Beatniks,
Bad Boys, and
Beautiful
Girls**

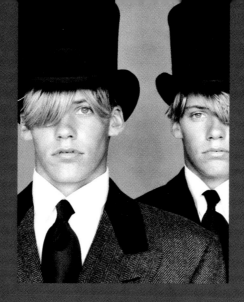

KEITH ALMOST PASSED OUT
DURING THE ESQUIRE
SHOOT. IT WAS A MUGGY
DAY IN NEW YORK CITY
AND WE WERE DRESSED IN
TRENCH COATS AND TOP
HATS. KEITH TURNED
GREEN BEFORE HE AGREED
TO TAKE A BREAK.

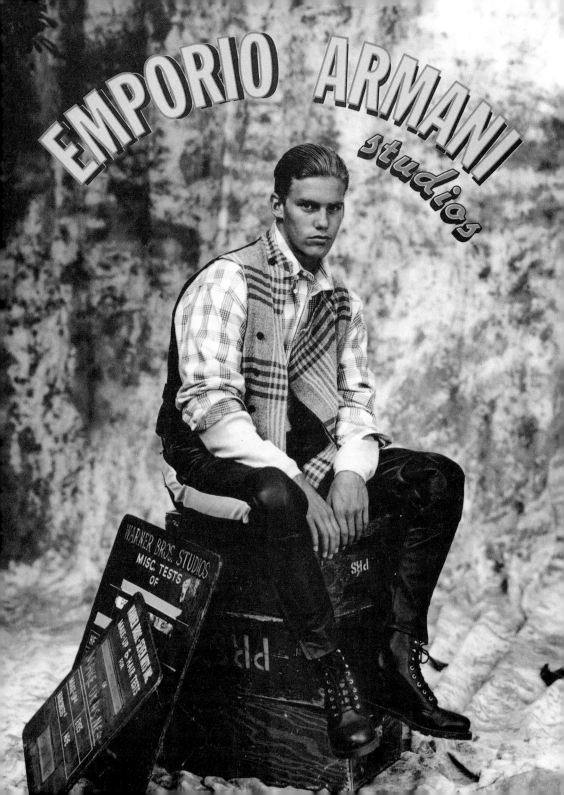

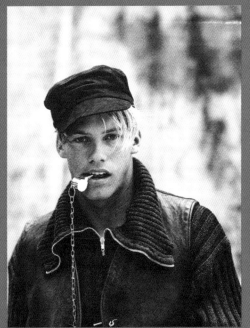

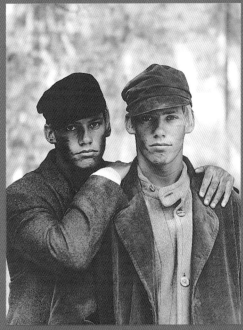

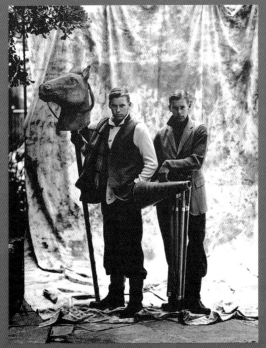

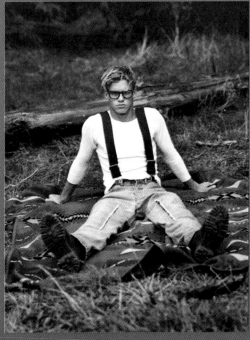

PHOTOGRAPHS BY
RANDALL MESDON
FOR MONDO UOMO

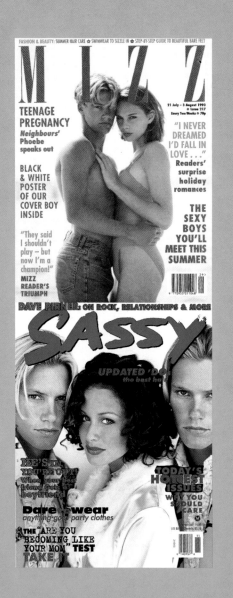

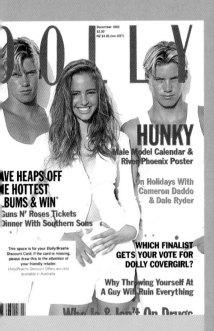

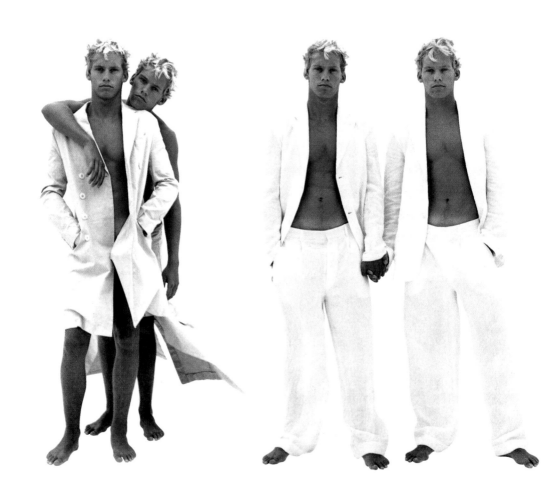

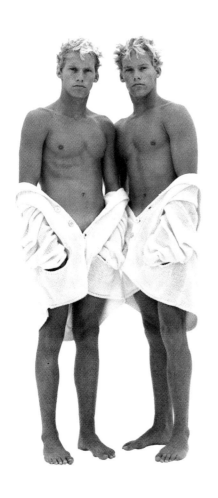

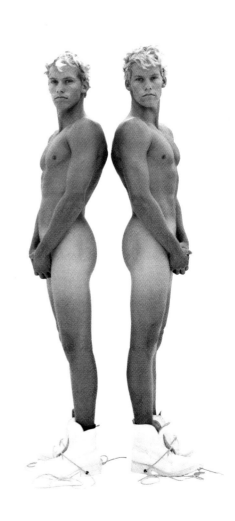

INTERNATIONAL VOGUE

PHOTOGRAPH BY PEGGY SIROTA

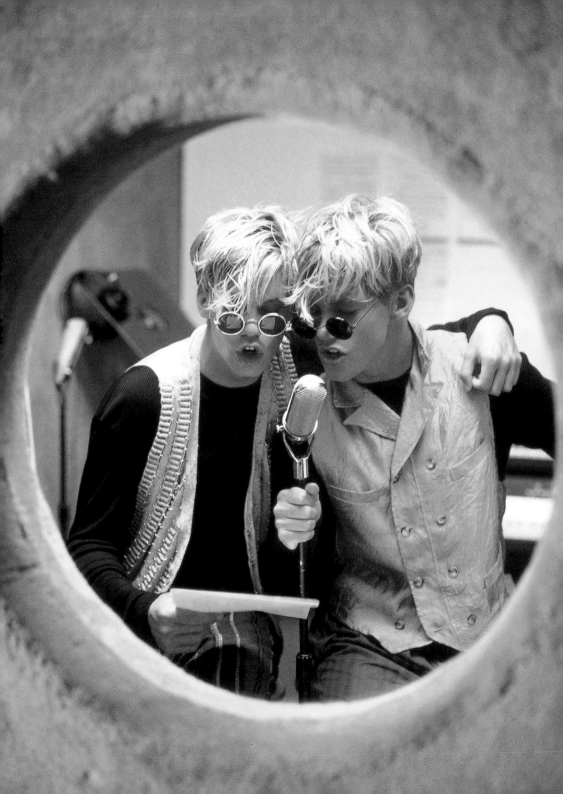

Brian Redding

SCAPA

FAVORITE PHOTOGRAPHER?

KEITH: RANDALL MESDON
DEREK: CLAUS WICKWRATH

PHOTOGRAPHS BY
RANDALL MESDON

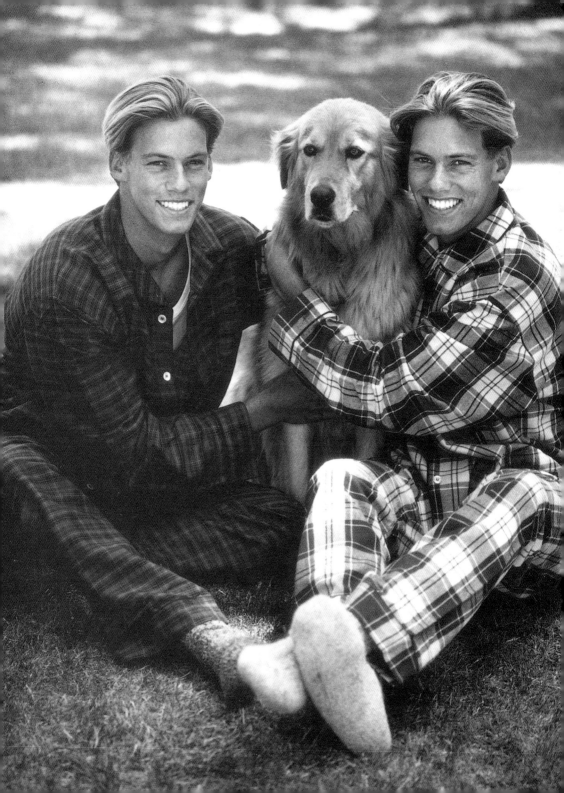

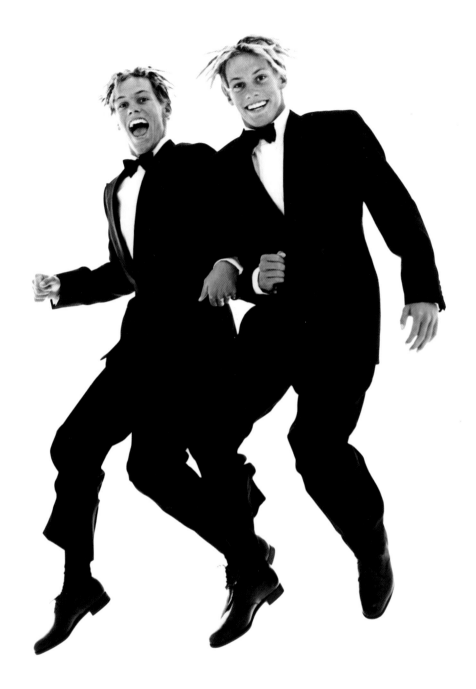

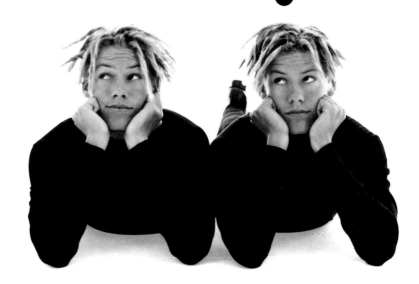

HARPER'S BAZAAR
PHOTOGRAPHER:
PATRICK DEMARCHELIER
AGE: TWENTY

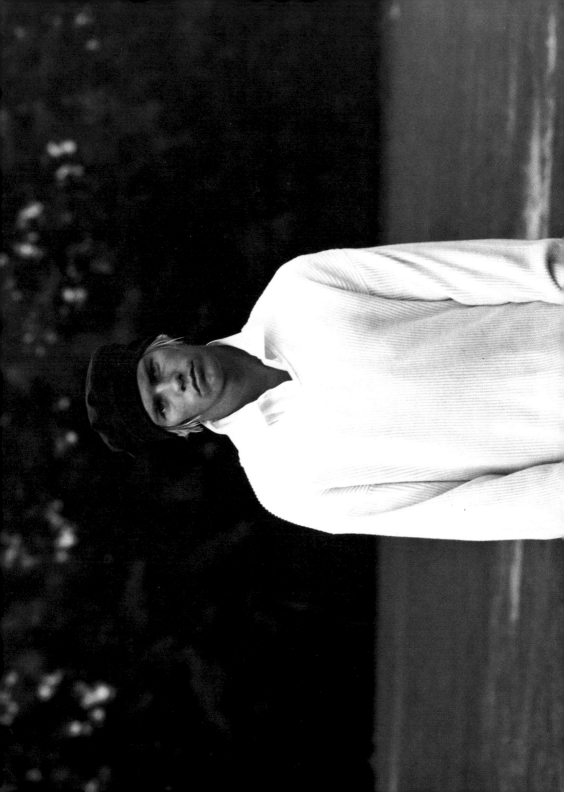

PHOTOGRAPH BY
DONALD MCPHEARSON

KEITH: KATIN & SKETCHERS
DEREK: MOSSIMO & DOC MARTENS

DAILY WEAR?

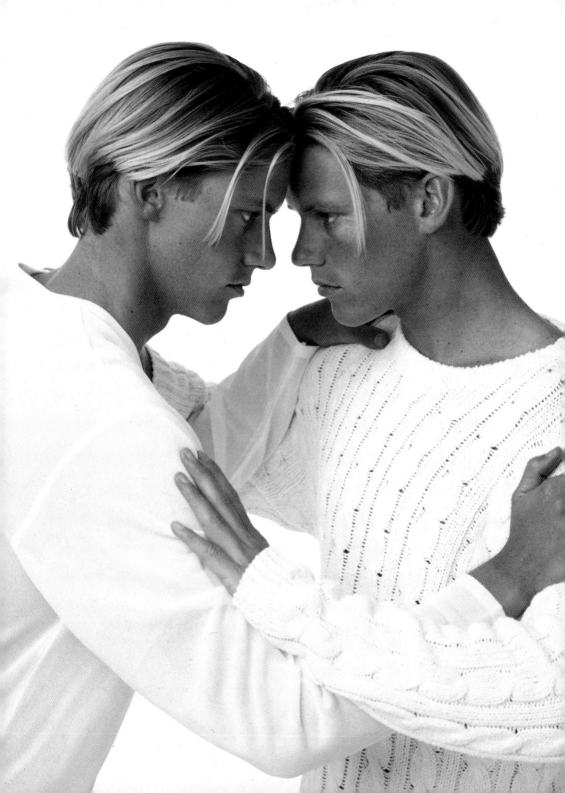

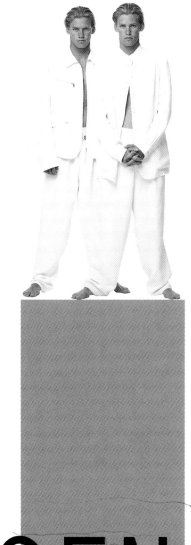

Fashion

GENRE

PHOTOGRAPHER: BLAKE LITTLE

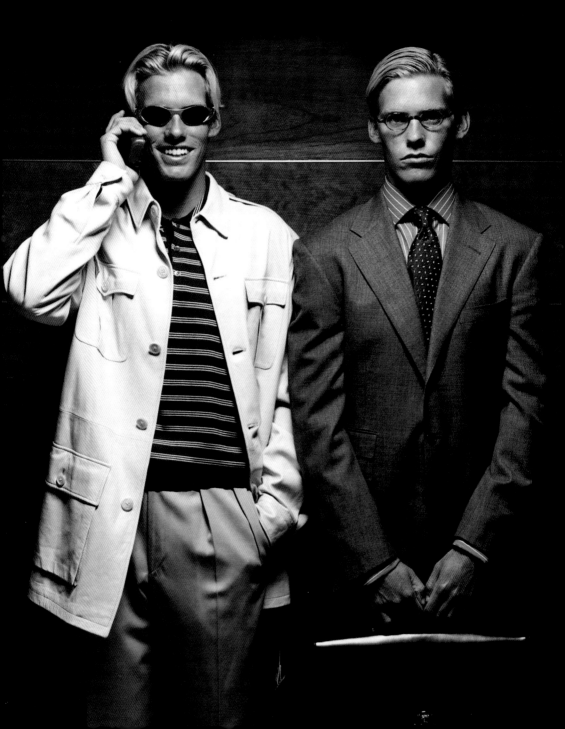

FORTUNE

DESIGNER?

PHOTOGRAPH BY
ROBERT TRACHTENBERG
FOR FORTUNE MAGAZINE

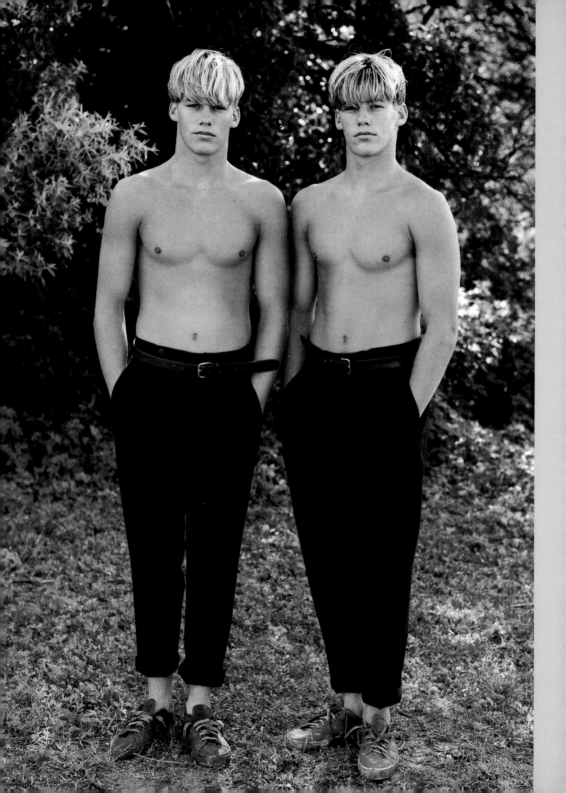

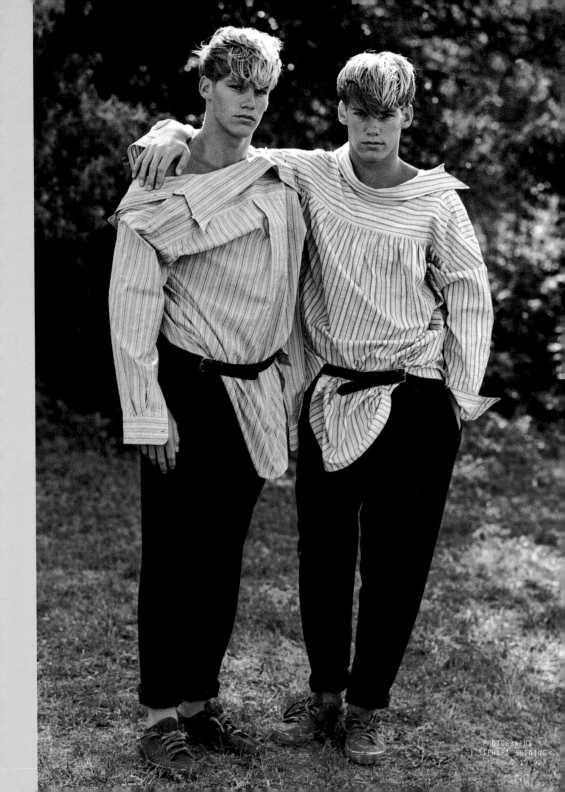

JOE

BRUCE WEBER

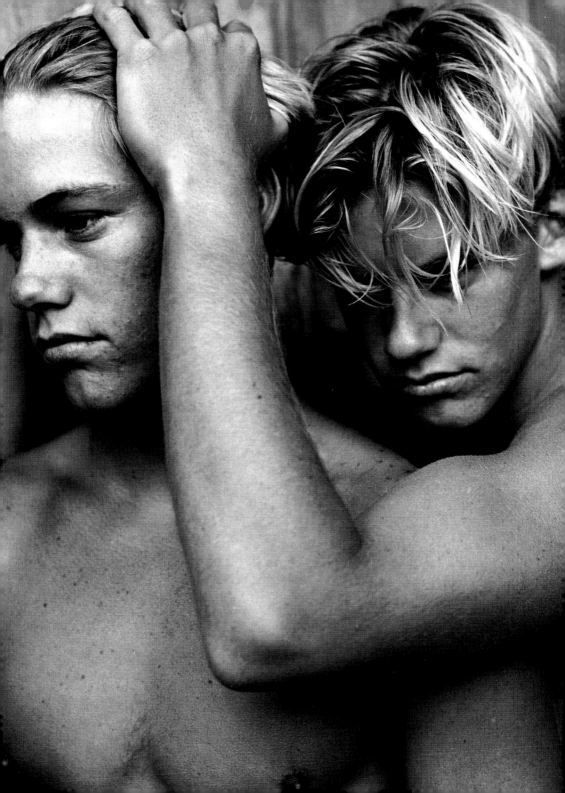

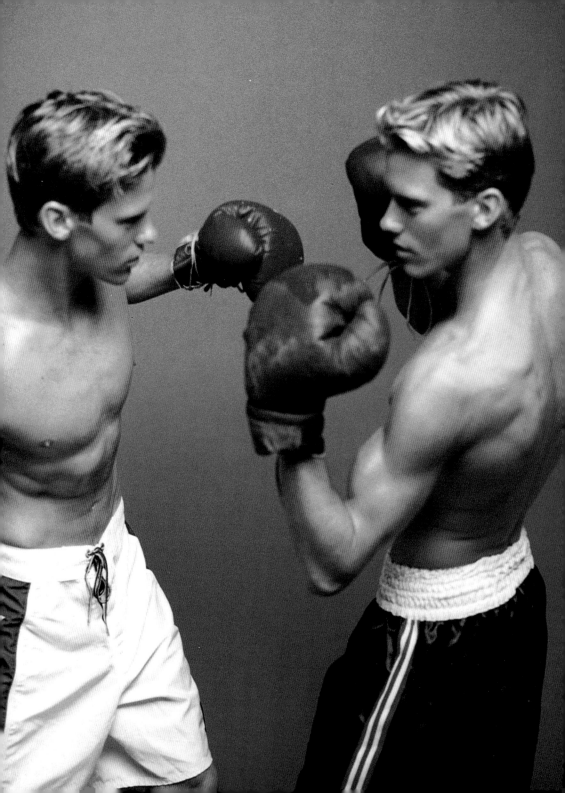

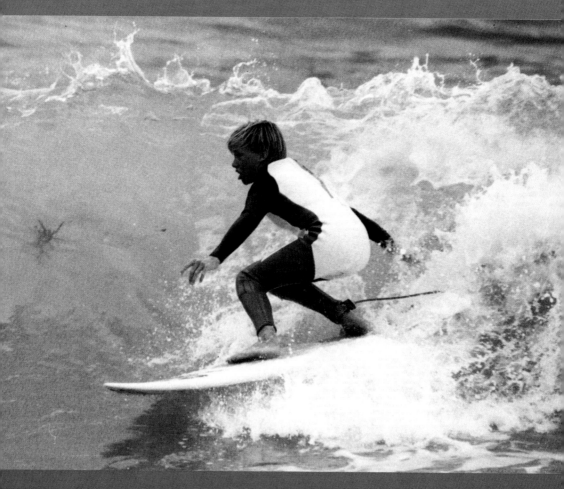

FROM THE FIRST DAY WE STOOD UP ON SURFBOARDS, WE WERE HOOKED.
AT FIRST IT WASN'T EASY, BUT WE WERE WILLING TO SPEND LONG
HOURS IN THE WATER, AND IF WE CAUGHT AT LEAST ONE WAVE, WE WENT
HOME HAPPY. SURFING QUICKLY BECAME OUR NUMBER-ONE PASSION. BY
THE TIME WE WERE FIFTEEN, WE STARTED COMPETING IN AMATEUR CON-
TESTS UP AND DOWN THE CALIFORNIA COAST. WE MET A LOT OF COOL
PEOPLE THIS WAY, AND PLACED IN THE TOP TEN FOR MANY SEASONS.

WE TOOK OUR FIRST MAJOR SURFING TRIP TO HAWAII WHEN WE WERE
FIFTEEN, AND WE THOUGHT WE'D DISCOVERED THE MEANING OF LIFE.
THE WAVES BROKE ON A REEF ABOUT A HALF-MILE OUT TO SEA, AND

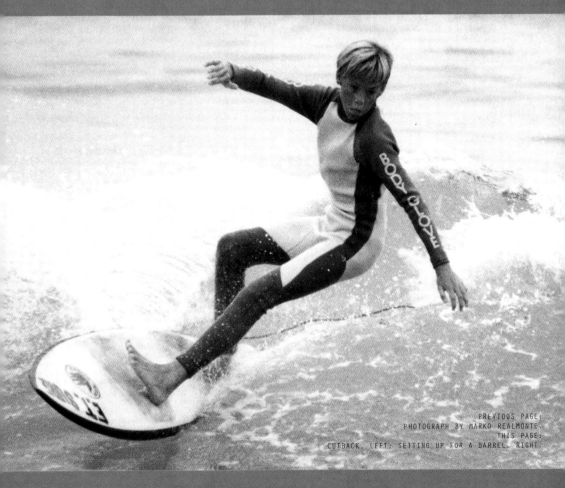

PREVIOUS PAGE:
PHOTOGRAPH BY MARKO REALMONTE.
THIS PAGE:
CUTBACK, LEFT; SETTING UP FOR A BARREL, RIGHT.

THE WATER WAS WARM. WE WERE ABLE TO SURVIVE ON JUST $250 FOR THREE WEEKS BY GOING TO AN "ALL YOU CAN EAT" BUFFET: DEREK WOULD EAT FIRST, THEN WE'D SWITCH CLOTHES AND KEITH WOULD GET HIS FILL.

SINCE THEN, WE'VE SURFED SOME OF THE WORLD'S BEST WAVES IN THE WORLD'S MOST BEAUTIFUL LOCATIONS, INCLUDING TAHITI (EXCELLENT TUBE RIDES), SOUTH AFRICA, INDONESIA, AND THE SOUTH OF FRANCE. AND, AT HOME IN HERMOSA BEACH, WE SURF EVERY DAY WE CAN. SURFING IS A LIFESTYLE FOR US—THERE'S NOTHING WE'D RATHER BE DOING.

SURF STATS

STANCE: REGULAR FOOT
BOARD: SPYDER
SIZE: 6'2" X 18$^{1/8}$" X 2$^{1/8}$"
CLOTHES: SPYDER & SPYDER BILT
WAX: STICKY BUMPS & SEX WAX

SURF SPOTS

CALIFORNIA: RINCON, SANTA BARBARA
HAWAII: SUNSET BEACH, OAHU
SOUTH AFRICA: JEFFERY'S BAY
SOUTH PACIFIC: TAHITI

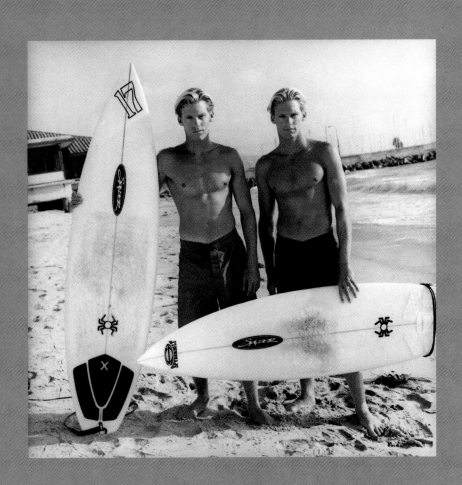

BIGGEST WAVE?

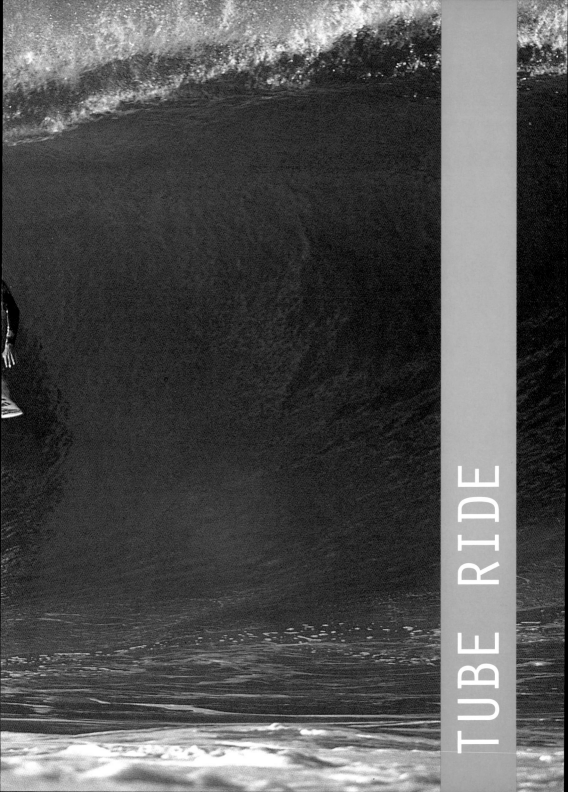

TUBE RIDE

SURF IDOL?

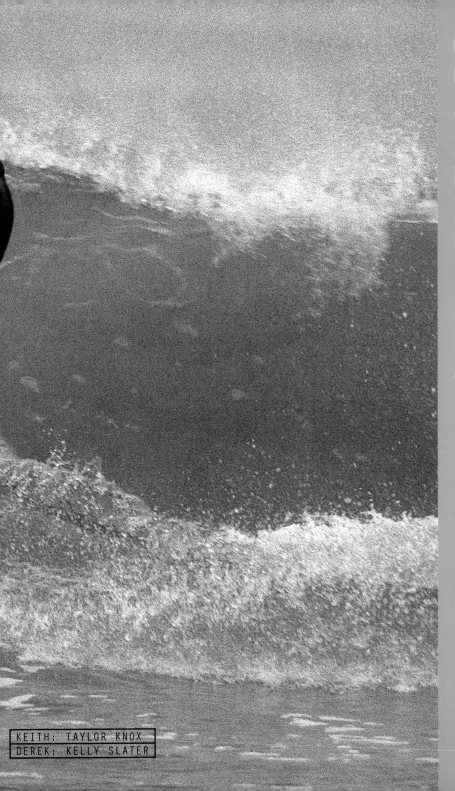

OFF THE LIP

KEITH: TAYLOR KNOX
DEREK: KELLY SLATER

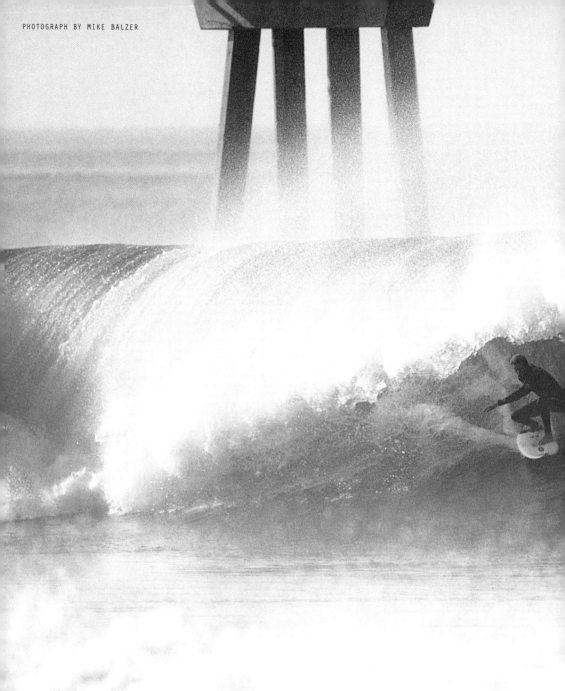

LONGEST RIDE?

KEITH: 45 SECONDS, RINCON
DEREK: 30 SECONDS, MALIBU

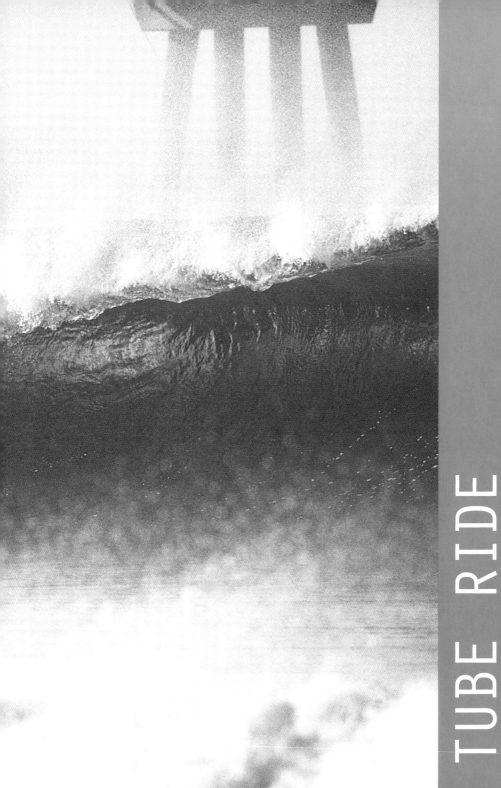

TUBE RIDE

WORST WIPEOUT?

KEITH: TAHITI
DEREK: SUNSET BEACH, HI

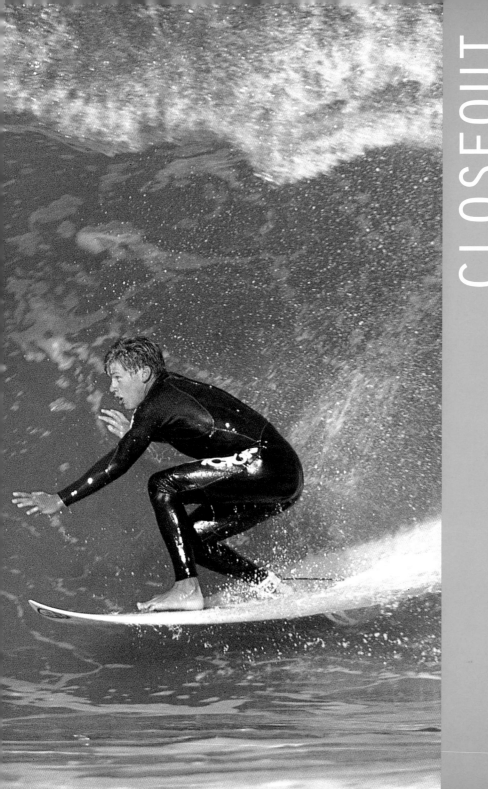

PHOTOGRAPH BY
MARKO REALMONTE

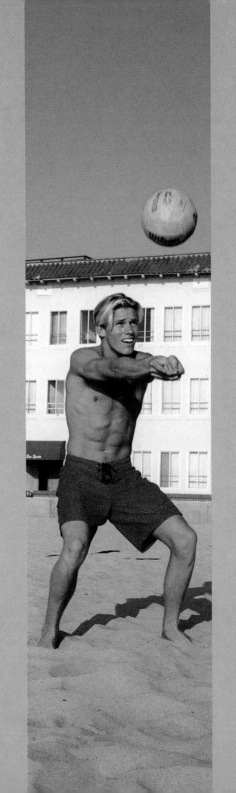

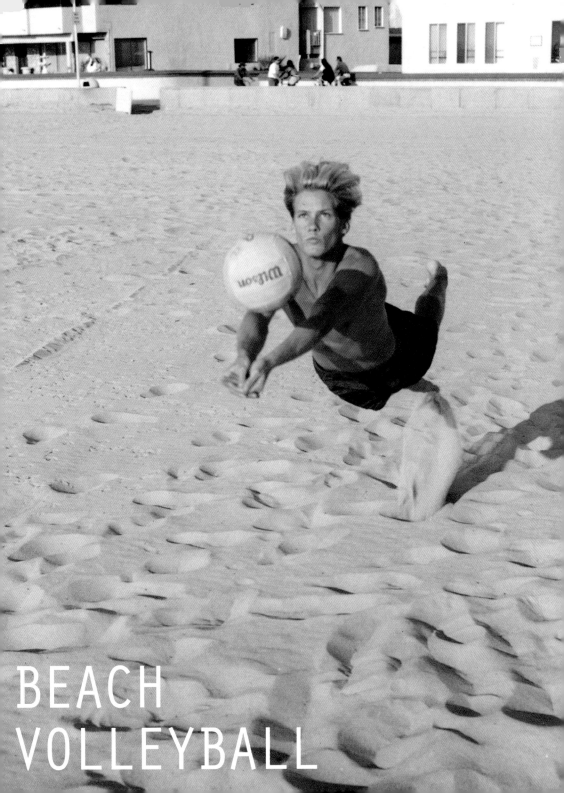

BEACH
VOLLEYBALL

SPLURGE?

PHOTOGRAPHS BY
MARKO REALMONTE

WORKOUT

WE GO TO THE GYM FOUR TO SIX TIMES A WEEK, DEPENDING ON THE SURF. WE TRY TO VARY OUR WEIGHT TRAINING A BIT AND ALWAYS KEEP SOME CROSS-TRAINING IN THE MIX. HERE'S OUR BASIC ROUTINE.

ROUTINE

AEROBIC: VOLLEYBALL, BIKING, SURFING
CHEST/BICEPS: FIRST DAY
BACK/TRICEPS: SECOND DAY
SHOULDERS/LEGS: THIRD DAY
ABS: 300 SIT-UPS EVERY DAY

BENCH?

PHOTOGRAPHS BY
MARKO REALMONTE

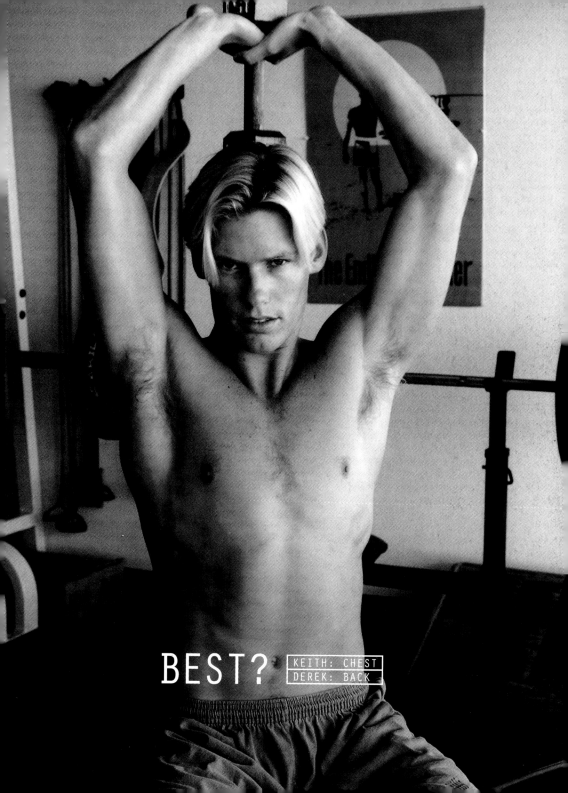

BEST?

KEITH: CHEST
DEREK: BACK

ALTHOUGH SNOWBOARDING IS A LOT LIKE SURFING, THE FIRST TIME WE TRIED IT FOUR YEARS AGO, WE TOOK A LOT OF DIVES. NOW WE

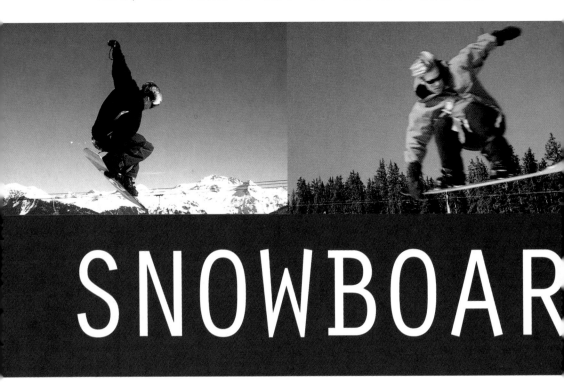

SNOWBOAR

BOARD?

KEITH: RUSTY, 155 CM.
DEREK: BURTON, 155 CM.

SNOWBOARD EVERY CHANCE WE GET. DEREK'S FAVORITE
MOUNTAIN IS MAMMOTH IN CALIFORNIA. KEITH
LOVES CORCHEVELL IN THE FRENCH ALPS.

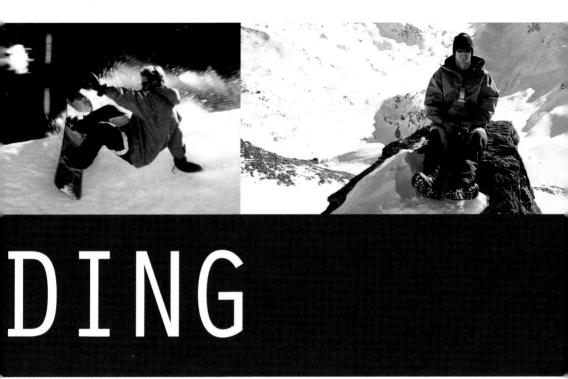

DING

BEST TRICK? KEITH: 180° TAIL GRAB
DEREK: METHOD AIR

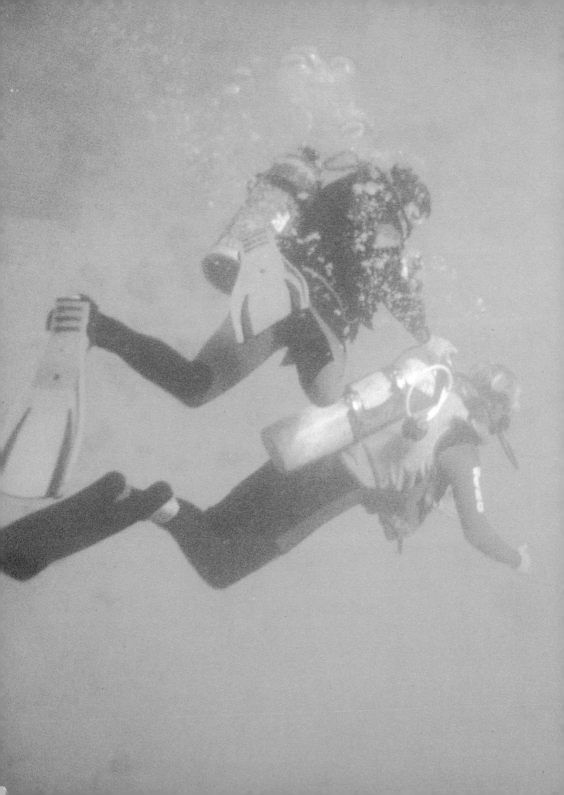

SCUBA

WHILE SHOOTING A
COMMERCIAL IN ISRAEL,
WE HAD THE OPPORTUNITY
TO GO SCUBA DIVING IN
THE RED SEA, ONE OF
THE MOST BEAUTIFUL
DIVING SITES IN THE
WORLD. IT WAS OUR
FIRST TIME DIVING, AND
IT WAS INCREDIBLE.

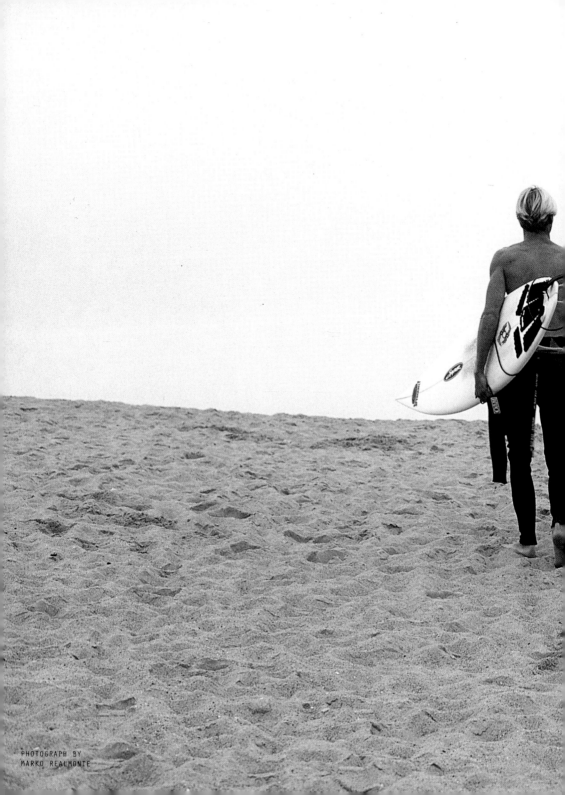

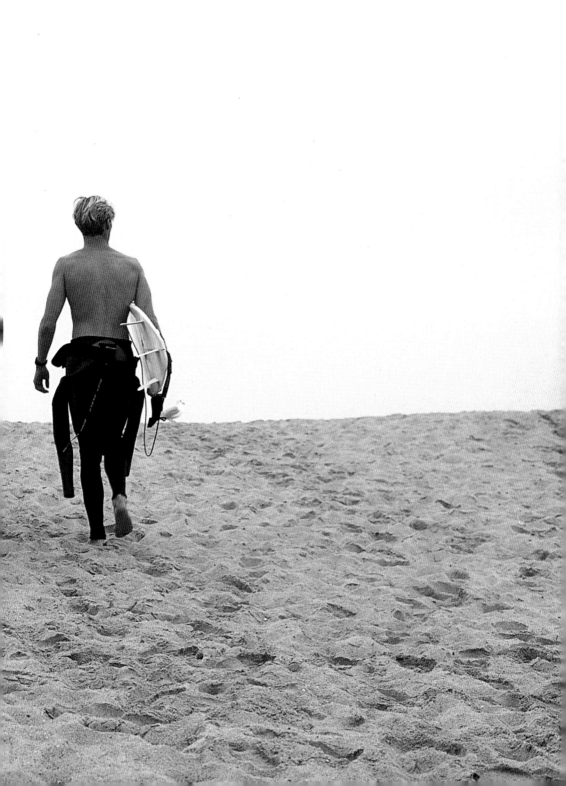

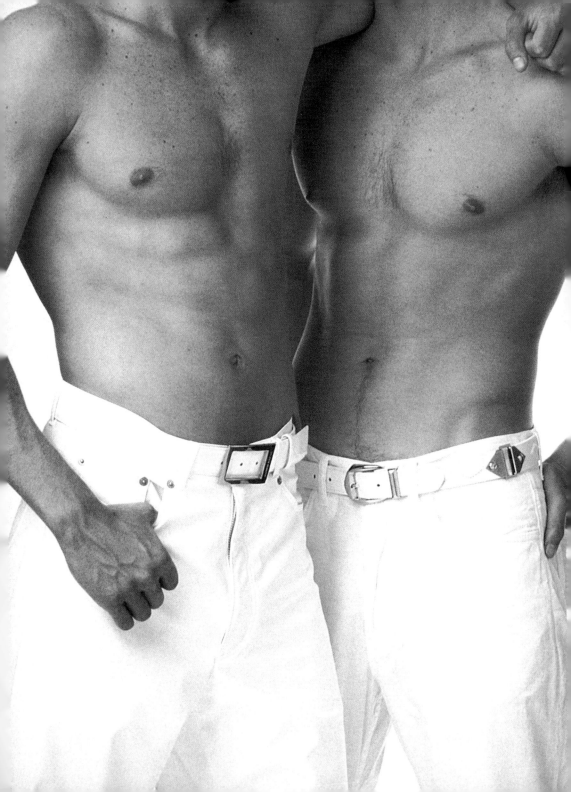

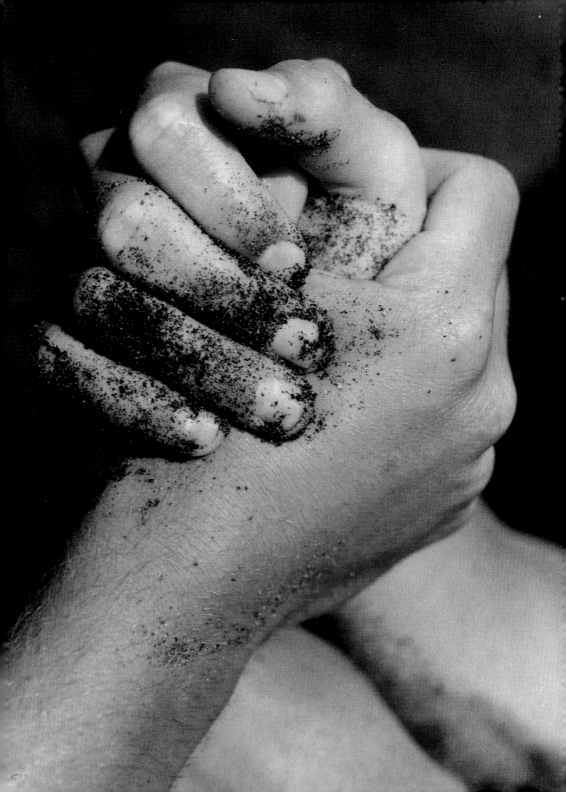

WITHOUT EXCEPTION, PEOPLE ARE FASCINATED BY TWINS. THEY ALWAYS WANT TO KNOW HOW TO TELL US APART AND, AFTER WE GIVE THEM A FEW TIPS, WE'LL CATCH THEM SCRUTINIZING OUR NOSES OR TRYING TO FIND KEITH'S SCAR. THEY'RE ALSO INTERESTED IN WAYS THAT WE'RE ALIKE BESIDES OUR LOOKS—LIKE THE FACT THAT WE WERE BOTH DEDICATED STUDENTS AND LOVE SURFING.

MOST OF ALL, PEOPLE LOVE STORIES ABOUT HOW WE CONFUSE OTHER PEOPLE, AND, WE MUST CONFESS, WE HAVE PLAYED THE TRADING PLACES GAME. LIKE THE TIME DEREK WAS PULLED OVER FOR SPEED-ING AND KEITH LET HIM USE HIS DRIVER'S LICENSE (BECAUSE HE'D JUST FINISHED A WEEK IN TRAFFIC SCHOOL AND COULDN'T AFFORD ANOTHER). OR THE TIME KEITH DECIDED THAT THE ONLY WAY HE'D GO ON ANOTHER DOUBLE DATE IS IF WE'D SWAP DATES (KEITH'S DATE THOUGHT IT WAS FUNNY, DEREK'S WAS NOT AMUSED). AND IT'S TRUE THAT DEREK'S BEEN KNOWN TO BORROW KEITH'S LITTLE BLACK BOOK...BUT WE DON'T WANT TO GIVE AWAY ALL OF OUR BEST TRICKS. INSTEAD, WE'LL GIVE A FEW TIPS ON HOW TO TELL WHO'S WHO—JUST TURN THE PAGE.

PREVIOUS PAGE:
PHOTOGRAPH BY
BLAKE LITTLE FOR GENRE.
LEFT:
PHOTOGRAPH BY
MARKO REALMONTE.

COPE? KEITH: MORE PATIENT
DEREK: STRAIGHTFORWARD

PERSONALITY? KEITH: FRIENDLIER
DEREK: HAS A TEMPER

ATTITUDE? KEITH: PERFECTIONIST
DEREK: MORE CASUAL

GIRLS? KEITH: DARK-HAIRED
 DEREK: BLONDS

GIRLFRIEND? KEITH: YES
 DEREK: LOOKING

ABS? KEITH: SYMMETRICAL
 DEREK: CRISS-CROSSED

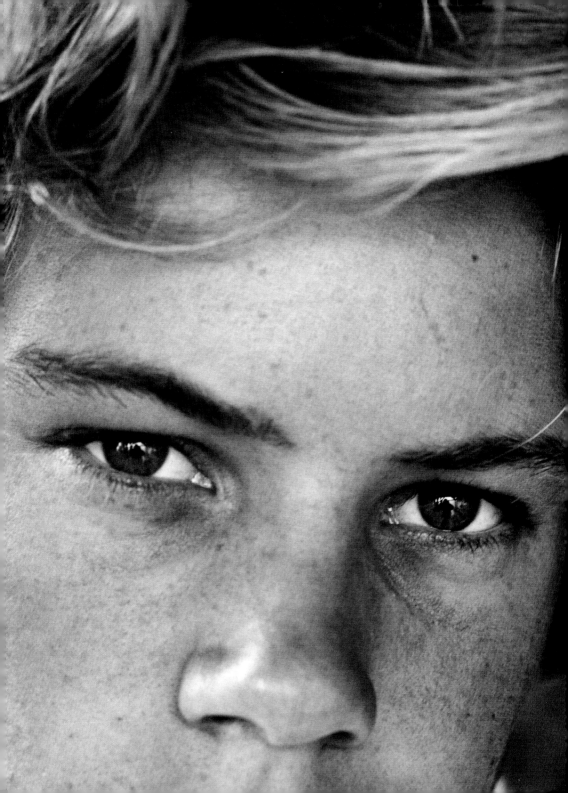

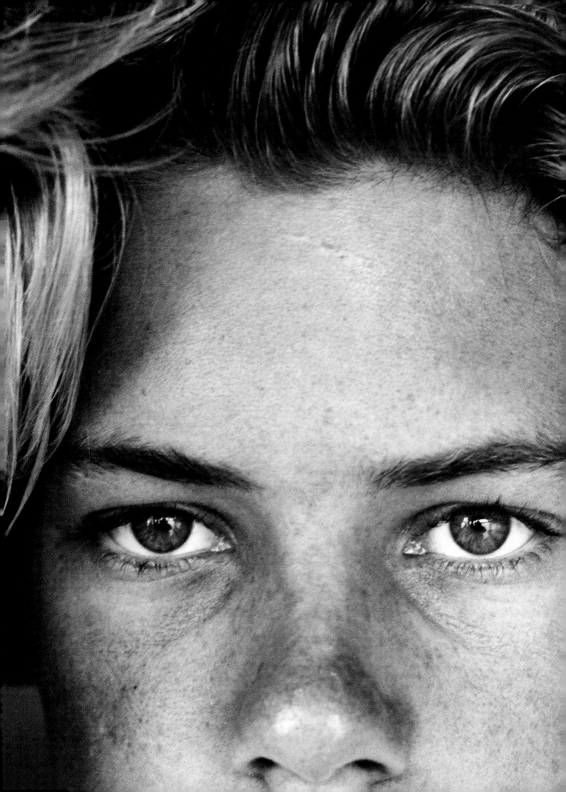

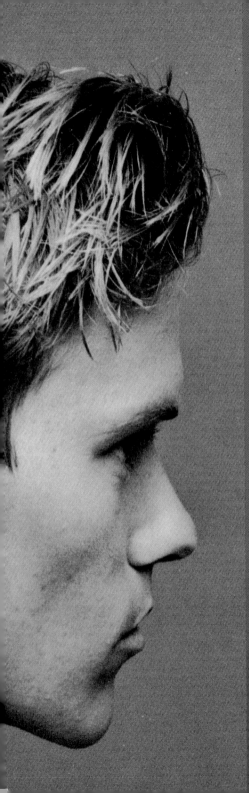

NOSE?

KEITH: STRAIGHT
DEREK: BUTTON

CHIN?

KEITH: BROADER, MORE SQUARE
DEREK: MORE TRIANGULAR

BEING A TWIN MEANS THERE'S ALWAYS SOME-
ONE TO HANG OUT WITH. WE SPEND A LOT OF
TIME TOGETHER, WHETHER WE'RE WORKING OR
JUST KICKING BACK. AND WE SHARE AN
APARTMENT WITH SOME OF OUR FRIENDS. THE
LONGEST WE'VE BEEN APART WAS A MONTH:

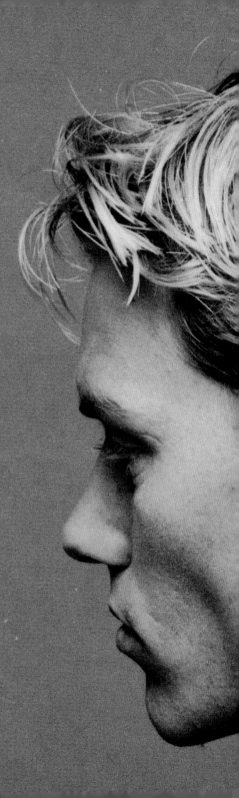

EYES?

KEITH: SCAR ON LEFT
DEREK: ROUNDER

SMILE?

KEITH: BIGGER
DEREK: MORE SUBTLE

PREVIOUS PAGE:
PHOTOGRAPH BY
BRUCE WEBER.
THIS AND FOLLOWING PAGE:
PHOTOGRAPHS BY
MARKO REALMONTE.

DEREK WAS WORKING IN PARIS, WHILE KEITH
GOT A JOB IN SPAIN. WE WORKED WELL ON
OUR OWN, BUT IT FELT STRANGE TO GO TO
THE GYM, CASTINGS, AND AGENCIES ALONE
WHEN WE'RE USED TO DOING THESE THINGS
TOGETHER.

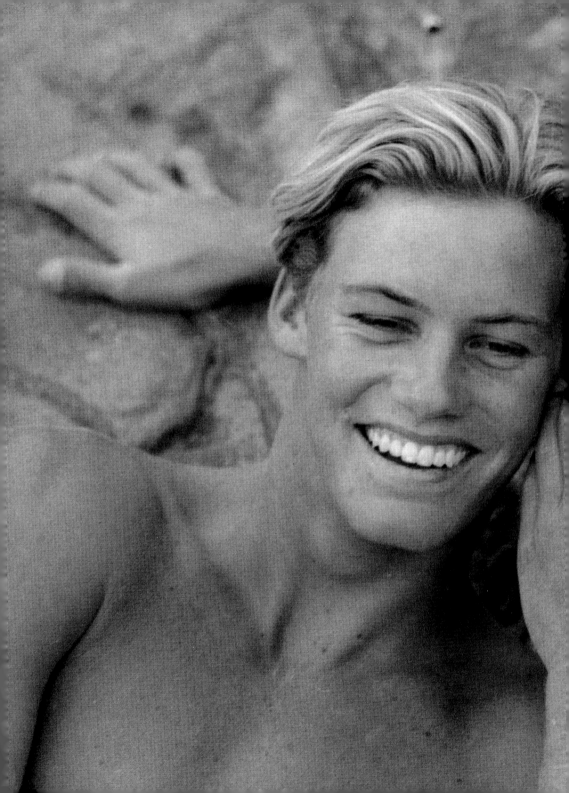

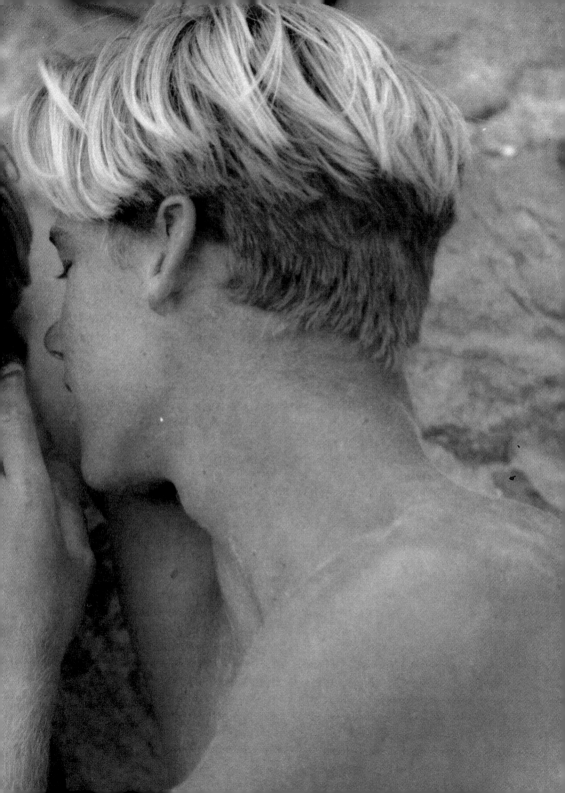

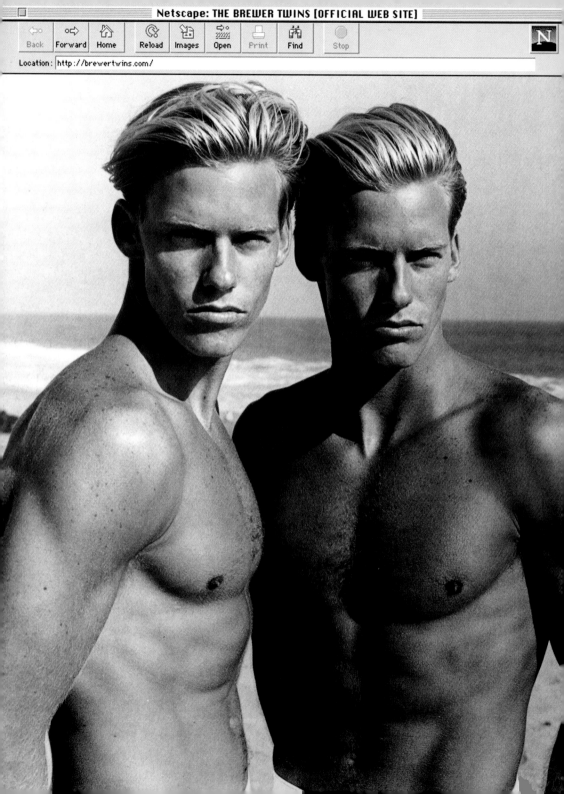

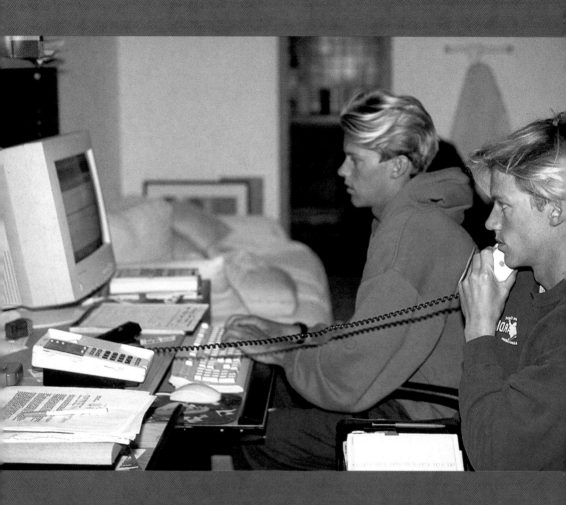

IN COLLEGE WE SPENT A LOT OF TIME ON-LINE DOING RESEARCH FOR OUR BUSINESS CLASSES, BUT IT WASN'T UNTIL 1997 THAT WE CRE-ATED OUR OWN HOMEPAGE. WE RECEIVED A LOT OF FAN MAIL AFTER WE APPEARED IN <u>MIZZ</u> MAGAZINE (A BRITISH TEEN MAGAZINE), AND REALIZED THAT ESTABLISHING OUR OWN WEBSITE WOULD BE THE IDEAL WAY TO STAY IN TOUCH. A GOOD FRIEND AND PHOTOGRAPHER WHO'S TAKEN MANY PHOTOS OF US HELPED US GET STARTED.

CREATING OUR OWN WEBSITE HAS BEEN AN INTENSE LEARNING PROCESS, BUT WE'VE HAD A GOOD TIME, AND EXPANDED THE CONTENT AND QUALITY RADICALLY. THESE DAYS OUR SITE RECEIVES THOUSANDS OF VISITORS AND TENS OF THOUSANDS OF HITS EVERY DAY. WE UPDATE IT REGULARLY WITH NEW PHOTOS, STORIES, AND STUFF FOR SALE (TURN THE PAGE FOR MORE INFO). WE ALSO RECEIVE E-MAIL AND TAKE QUESTIONS ON-LINE.

IN ADDITION TO OUR WEBSITE, OUR ADMIRERS HAVE ESTABLISHED AN AMAZING NUMBER OF SITES ABOUT US. BUT DON'T BE FOOLED! FOR THE REAL STORY AND THE MOST UP-TO-DATE PHOTOS, YOU HAVE TO LOG-ON TO OUR OFFICIAL SITE: WWW.BREWERTWINS.COM!

THE <u>OFFICIAL</u> WEBSITE:

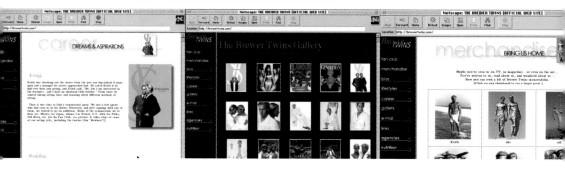

CAREER

HERE YOU CAN FIND
OUT MORE ABOUT OUR
MODELING AND ACTING
CAREERS. WE ALSO
OFFER ADVICE TO
ASPIRING MODELS.

GALLERY

OUR GALLERY INCLUDES
TONS OF PHOTOS FROM
OUR MODELING JOBS
AND ALSO MORE PER-
SONAL PHOTOS WHEN
WE'RE <u>NOT</u> WORKING.

MERCHANDISE

WE SELL LIMITED-
EDITION PHOTOS AND
POSTERS ON THE WEB.
SOMETIMES WE'VE
EVEN TAKEN FANS'
SUGGESTIONS ABOUT
POSES!

VISITS: 3026 PER DAY

WWW.BREWERTWINS.COM

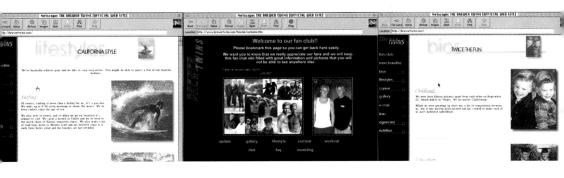

LIFESTYLES

AS YOU KNOW BY NOW,
SURFING ISN'T JUST A
HOBBY FOR US, IT'S
A WAY OF LIFE. THE
SITE INCLUDES THE
DETAILS OF OUR WORK-
OUT AND DIET REGIME.

FAN CLUB

IF YOU JOIN THE
BREWER TWINS' FAN
CLUB, YOU RECEIVE
ACCESS TO EXCLUSIVE
PHOTOS, VIDEO AND
AUDIO CLIPS, OUR
DAY-TO-DAY SCHEDULE,
AND CONTESTS.

BIOS

THIS SECTION PRO-
VIDES THE BASICS:
WHERE AND WHEN WE
WERE BORN, OUR SIGN,
WHAT IT WAS LIKE TO
GROW UP AS TWINS,
AND STORIES FROM OUR
COLLEGE DAYS.

HITS: 34,737 PER DAY

COMPUTER FIND:
"BREWER TWINS"
=381

COMPUTER FIND:
BREWER TWINS
=315,610

SCREEN CAPTURES TAKEN
FROM THE UNOFFICIAL
SITES THAT CARRY

e you a model?

le are constantly telling you that you should model, then maybe you should.

aways looking for great, new people to shoot with. The terrific thing about what I do is that everyone is different - every person has a ory and a different look.

are already a model, then maybe you want to see what my vision of you would be like

ing is a collaboration . I hope that you get a sense of that from my pages . It is my talent, my eye and vision combined with the beauty person I'm shooting . I love it when a model has great ideas for pictures . I get excited when people are fearless, willing to ment and try new things . Explore

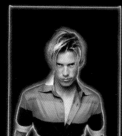

Netscape: Brewer Twins 10

Netscape: brewer twins site

the Brewer Twins have moved...

twins, grewer twins, brewer twins, brewer twins B

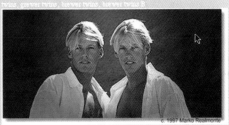

c 1997 Marko Realmonte

brewertwins, brewer twins, brewer twins, brewer twins, brewer twins, brewer twins, brewer twins, brewer twins, brewer twins, brewer twins, brewer twins, brewer twins, brewer twins, brewer twins, brewer twins, brewer twins, brewer twins, brewer twins, brewer twi...

Our official site, and new domain can be found at: Brewer twins
brewer twins, brewer twins, brewer twins, brewer twins, brewer twins, brewer twi...
www.brewertwins.com Brewer Twins, Brewer twins, Brewer Twins

(just click on the underlined title or on the photo to go directly to our site) Brewer Twins
Brewer Twins, Brewer Twins, Brewer Twins, Brewer Twins, Brewer Twins, Brewer Twins

Netscape: The Brewer Twins - The most famous and most popular twins this

Netscape: JPEG image 306x416 pixels

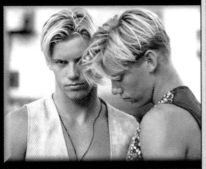

Derek and Keith Brew

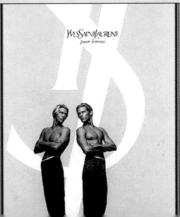

ACKNOWLEDGMENTS

THERE ARE A LOT OF PEOPLE WE'D LIKE TO THANK FOR THEIR ROLES IN THE MAKING OF OUR BOOK. FIRST OF ALL, WE WOULD LIKE TO THANK OUR PARENTS FOR GIVING US THE ESSENTIAL TOOL OF SUCCESS IN THIS BUSINESS—OUR LOOKS. IN ADDITION, WE WOULD LIKE TO THANK THEM FOR BEING SO SUPPORTIVE OF OUR CAREER AND STILL PUSHING US TO FINISH COLLEGE. THERE WERE A FEW TIMES WHEN WE JUST WANTED TO QUIT SCHOOL AND MODEL, BUT OUR FOLKS WERE THERE TO KEEP OUR HEADS ON STRAIGHT. WE WOULD LIKE TO THANK ALL OF OUR FRIENDS AND FAMILY FOR KEEPING US GROUNDED, ESPECIALLY JON WILLIAMS, JARED FRIEDMAN, LARRY BURKS, JENNY ELL AND FAMILY, HOWARD EDDY, CHRIS POLLICK, JASON PURSLEY, MATT WALLS, DEREK GONZALES, GREG BROWNING, SIM AND DINO BARHOUM, AND EVERYONE AT "16TH STREET."

WE ARE GRATEFUL TO PAUL WEST FOR CONCEPTUALIZING THE BOOK AND INTRODUCING US TO EVERYONE FROM UNIVERSE: THE PUBLISHER, CHARLES MIERS, GRAPHIC DESIGN ARTIST JASON LOSSER, AND EDITOR SARAH SCHEFFEL. WE WOULD ALSO LIKE TO ACKNOWLEDGE OUR AGENCIES WORLDWIDE FOR GETTING US TO THE POINT THAT WE ARE AT NOW.

WE ARE VERY THANKFUL TO STEVEN MEISEL, WHO GAVE US OUR FIRST BIG BREAK BY USING US FOR THE COVER OF ITALIAN GLAMOUR. WE GIVE SPECIAL THANKS TO MARKO REALMONTE, A PHOTOGRAPHER WHO HELPED US BUILD OUR MODELING PORTFOLIOS AND BELIEVED IN US FROM DAY ONE OF OUR CAREERS. WE WOULD LIKE TO THANK ALL OF THE OTHER PHOTOGRAPHERS WHO HAVE CONTRIBUTED THEIR PICTURES FOR THE USE IN THIS BOOK AND ALL OF THE STYLISTS AND MAKEUP ARTISTS WHO HELPED US LOOK OUR BEST FOR OUR MODELING JOBS.

PHOTOGRAPH BY
MARKO REALMONTE

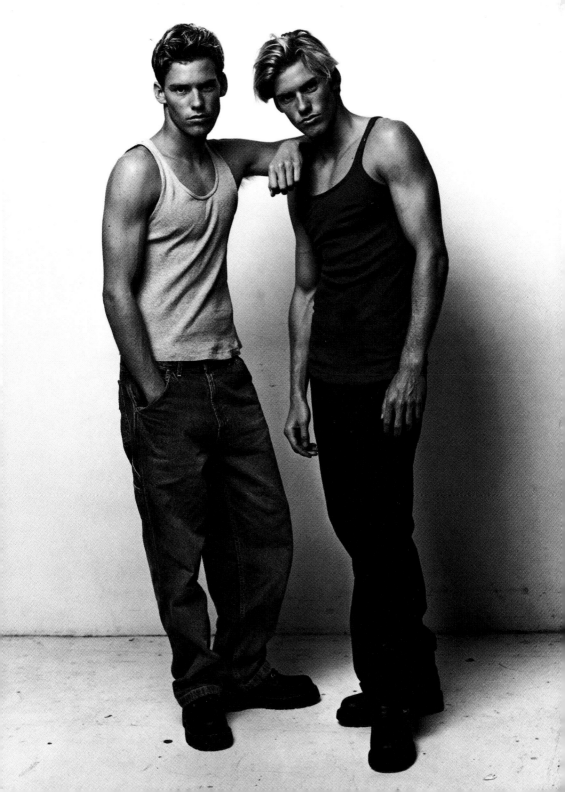

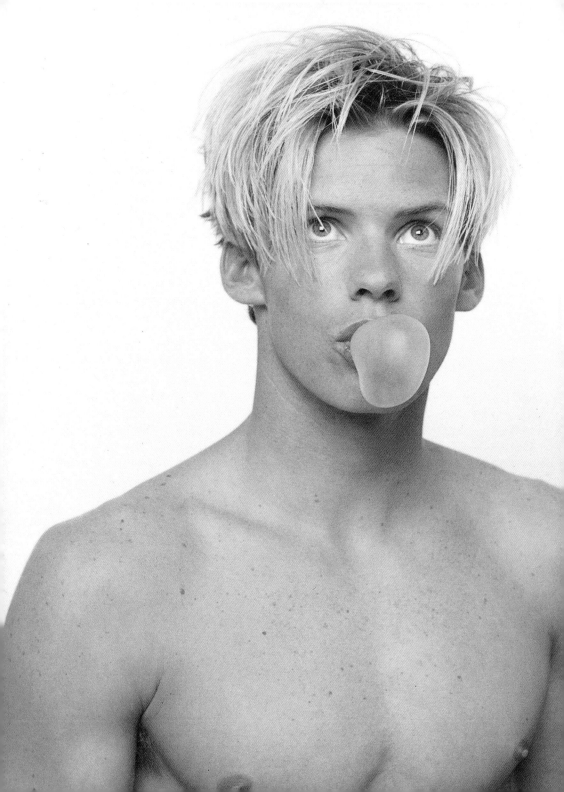

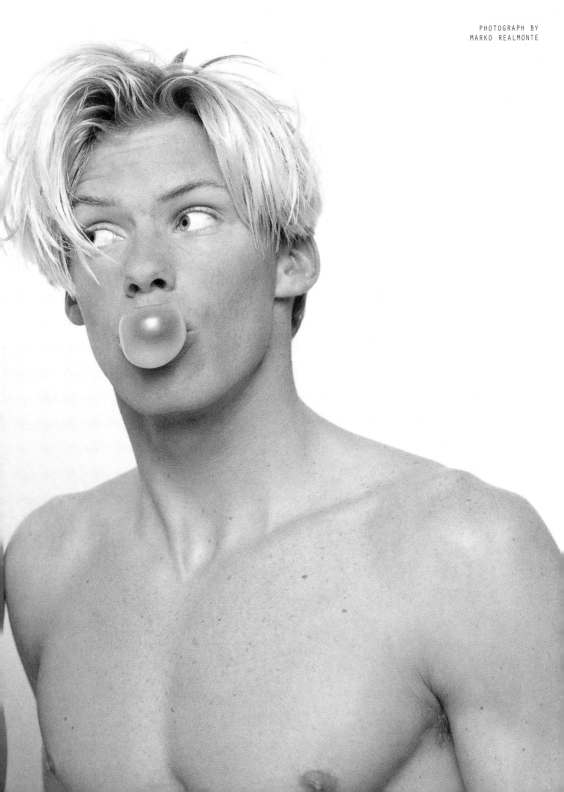

PHOTOGRAPH BY
MARKO REALMONTE

CONTRIBUTING
PHOTOGRAPHERS

ALAI
CARLOS ARMANDO
MIKE BALZER
PATRICK DEMARCHELIER
MICHAEL HABER
MARC HOLM
BARRY KING
BLAKE LITTLE
TIZIANO MAGNI
DONALD MCPHEARSON
STEVEN MEISEL
RANDALL MESDON
MARKO REALMONTE
HERB RITTS
JOHNNY ROZSA
STEWART SHINING
PEGGY SIROTA
VICTOR SKREBNESKI
ROBERT TRACHTENBERG
BRUCE WEBER
CLAUS WICKRATH

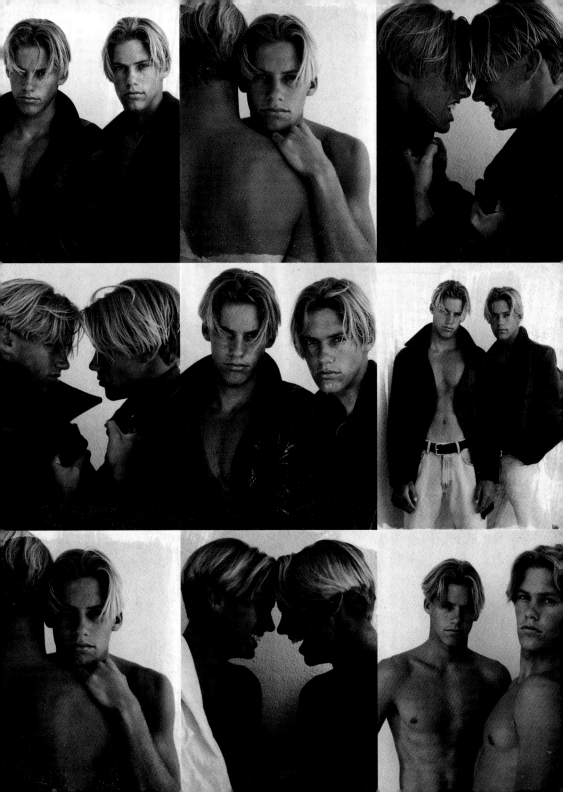